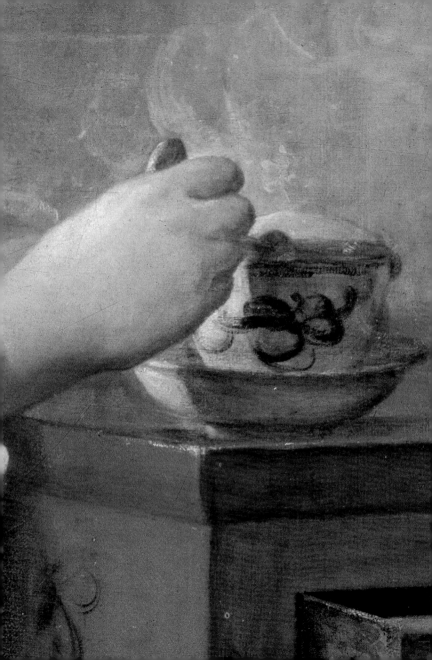

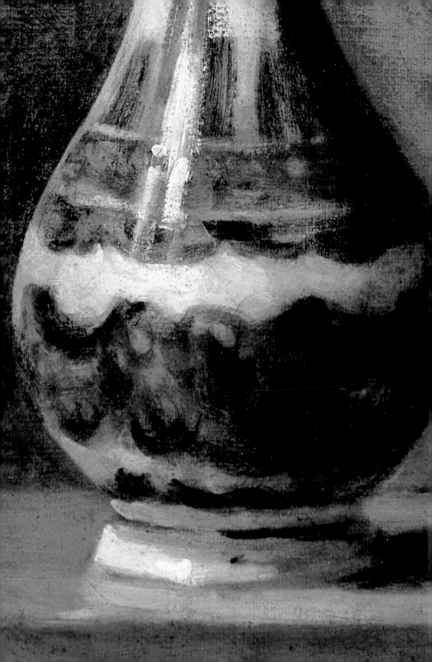

CONTENTS

1 THE DIFFICULTY OF DISCUSSING CHARDIN
13

2 CHARDIN AND HIS AGE
37

3 CHARDIN AT WORK
61

DOCUMENTS
97

Chronology
118

Further Reading
120

List of Museums
120

List of Illustrations
121

Index
125

CHARDIN
AN INTIMATE ART

Hélène Prigent and Pierre Rosenberg

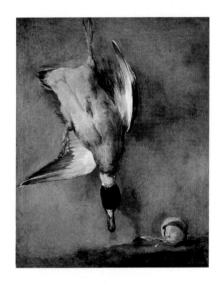

Thames & Hudson

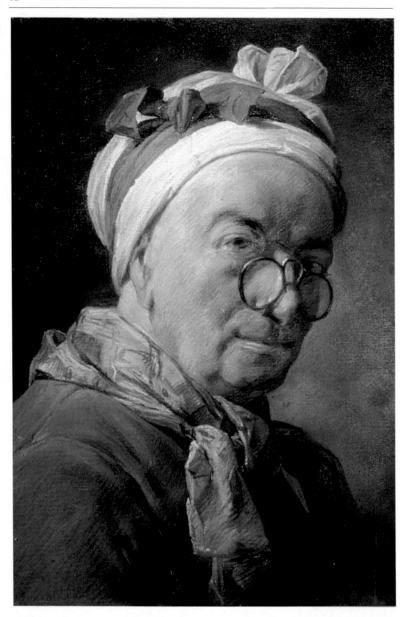

Jean Siméon Chardin is an enigmatic figure. Although we know he was hailed by his contemporaries, especially Diderot, as a great master of still-life painting, he remains an elusive character. His correspondence offers no clues, and even the biographers of his own day found him a difficult man to describe.

CHAPTER 1

THE DIFFICULTY OF DISCUSSING CHARDIN

Few portraits of Chardin exist and he did not paint himself until he was seventy-two – *Self-portrait*, also known as *Portrait of Chardin with Spectacles* (1771; opposite). Unusually for a man of his day, he chose to represent himself without wig or formal clothes.

At first sight there seems to be plenty of information about the life and works of Jean Siméon Chardin. The artist was born on 2 November 1699 and achieved early fame and considerable popular success, thanks to the wide distribution his works received in the form of prints and engravings. He was born at the start of the 18th century, when modern art criticism was invented. He exhibited regularly and was mentioned frequently in the press, as well as figuring extensively in the writings of one of the foremost literary figures of the period, Denis Diderot (1713–84), a friend and collector of his works (although none of this material was published until the following century).

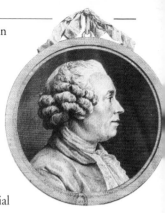

Essay sur la vie de M. chardin

Jean simeon chardin; Peintre celebre dans son genre
bien faire les Billards; Il avoir chargé de ceux qu'on faisoit pour
fils cadet qui l'Exerce encore la continué avec le même succès.*

In parallel with his career as a painter, Chardin carried out official duties at the Académie Royale de Peinture et de Sculpture, and his name appears regularly in the records of its meetings. He was far from being an unknown in his own lifetime. However, in spite of his relative fame, our understanding of Chardin comes up against certain major obstacles, some to do with sources of information, others to do with the character of the artist.

Pierre-Jean Mariette (left) was one of the greatest collectors of drawings and engravings of his time. He was in regular contact with artists and connoisseurs all over Europe. As well as many erudite catalogues, he produced an *Abecedario* with a text on Chardin. His collection was dispersed at his death, but a major part was acquired for the Cabinet du Roi and may now be seen in the Louvre.

Limited sources

Although Chardin's contemporaries wrote a lot about his work, few spoke of the man himself. Diderot makes the occasional reference, nothing more. Apart from the paintings, all we have from Chardin himself are a few letters dealing with administrative or professional matters, seeking a post or settling his accounts. There remain his three biographers: Pierre-Jean Mariette, a dealer in prints and later art historian and collector, wrote an article on the painter in 1749; Haillet de Couronne, secretary of the Académie of Rouen with which Chardin was associated wrote his eulogy; and, finally, Charles-Nicolas Cochin, secretary and historiographer of the Académie Royale de la Peinture et de Sculpture, was the author of an 'Essai sur la vie de M. Chardin'.

etvit fils d'un mennisier qui servit distingué par le Talent de le Roy. Ce Talent a été hereditaire dans sa famille et son

Mariette's article was written during the artist's lifetime, but not published until 1853, seventy-four years after Chardin's death. The other two pieces were written in the year following Chardin's death in 1780. None of the three says much about the painter's personality. Mariette offers details of his childhood and early career. Haillet de Couronne and Cochin both describe a simple, unpretentious man, straightforward and hardworking, a decent fellow in fact – very much the image perpetuated by the Goncourt brothers (the French novelists Edmond and Jules, who constituted the famous 19th-century literary partnership), which has come down to us unchanged.

In practice the last two sources are one, as Haillet de Couronne took all the information required for his eulogy from Cochin and merely recycled the facts. We should therefore concentrate on Cochin.

Charles-Nicolas Cochin the Younger (1715–90; opposite top) was an illustrator, engraver and art critic. As secretary of the Académie Royale de Peinture et Sculpture, he played an important role in the administration of the arts, acting between 1755 and 1774 as adviser to the Marquis de Marigny, Directeur des Bâtiments, Jardins, Arts et Manufacture to the king. He executed one of the rare portraits of Chardin (above).

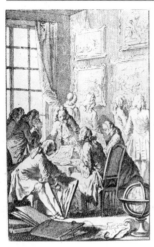

Chardin's friend Charles-Nicolas Cochin

Cochin's father was one of Chardin's most distinguished illustrators. In the 18th century, engraving was an important method of reproduction that helped an artist reach a wider audience, providing a significant income for both engraver and painter. Chardin thus had financial interests in

This gathering of print collectors by Cochin (left) is both a genre scene and a charming social study, in which Cochin the eminent collector seems to make fun of his hobby: grown men getting worked up over a few pictures.... In the 19th century the French caricaturist Honoré Daumier gave the theme a more satirical slant.

Servant Filling a Player's Glass (detail, below) is a preparatory drawing for the group of figures shown on the left in *Game of Billiards* (opposite). A number of details were modified in the later picture, notably the servant's body, which is tilted further forward in the final version.

Par M. COCHIN , *Chevalier de l'Ordre du Roi , Secrétaire de l'Académie.*

common with Chardin senior. His relationship with the son was quite different. Both men held posts at the Académie and met frequently. In his official capacity Cochin was responsible for the 'administration of the arts'. On several occasions he was able to obtain commissions and allowances for Chardin, as well as an apartment at the Louvre where he himself lived.

In the background material he put together for Haillet de Couronne's *Eloge*, Cochin omitted an anecdote that he told to the director of the Académie of Rouen. Apparently Chardin had paid a visit to the distinguished collector Crozat, Baron de Thiers, and, on being turned away, had pushed one of the servants down the stairs. Whatever the truth of this anecdote, mentioned only by Cochin, it does indicate that he imposed certain restrictions on himself when discussing Chardin: 'If, as I suspect is the case, it would scarcely do honour to our friend's memory, then

it does not serve our purpose.' It may also be legitimate to infer from this anecdote that Chardin was by nature quick-tempered.

Clearly it would be wrong to expect total objectivity from Cochin, but at least we can rely on the facts he does report. Though willing to omit certain details, he does not appear prepared to invent them: 'In a eulogy, although we may extol the qualities of our friends, we are obliged in conscience not to ascribe to them those they never possessed,' he wrote to Haillet de Couronne.

Apprentice years

Jean Siméon Chardin was born in the Rue de Seine, Paris, and grew up in a bourgeois family of artisans. His father was a master cabinet-maker who, according to Cochin, 'had distinguished himself with his talent for making billiard tables' and his godfather and god-mother's husband were both cabinet-makers. Jean Chardin naturally hoped his son would follow the family tradition. As his son was 'loath' to do so, 'his father accepted his inclination for painting.... Since M. Chardin the Elder, who had a large family, could not

Probably a tribute to the traditional family occupation followed by the painter's younger brother Juste Chardin, *Game of Billiards* (c. 1722–4; below) is one of the artist's earliest canvases. It includes many more figures than the later works, but set already against the same brown walls. The tiles on the floor emphasize perspective. The illegible notice on the right-hand wall is probably a list of police regulations for public places.

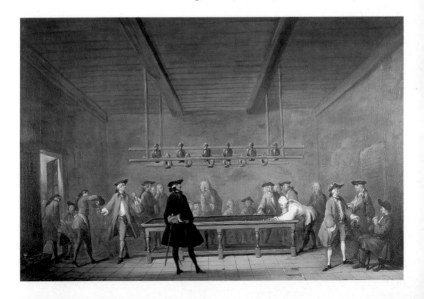

have hoped to leave his children an adequate inheritance, as it would have to be split up between them, he tried only to give them enough skills to enable them to earn a living. This is why he did not concern himself with making them learn the classics.'

Once the decision had been made, no time was lost in turning Chardin into a painter. His father apprenticed him to Pierre-Jacques Cazes, a history painter who had no funds to pay for models and used to ask his pupils to copy his own paintings. Then in 1724, apparently

Pierre-Jacques Cazes (1676–1754; left), who taught Chardin, belonged to the older generation. He was received by the Académie in 1703, appointed director in 1743 and chancellor in 1746. He took part in the competition for the Galerie d'Apollon of the Louvre in 1727 and subsequently executed a large number of religious commissions for churches in Paris and Versailles. His history paintings are in the academic tradition of the French painters Charles Le Brun (1616–90) and Charles de Lafosse (1636–1716). He also produced mythological works and lighter genre scenes. This portrait of the artist in his wig, with his portfolio of drawings, was the reception piece submitted to the Académie Royale in 1734 by Chardin's friend Joseph Aved (1702–66).

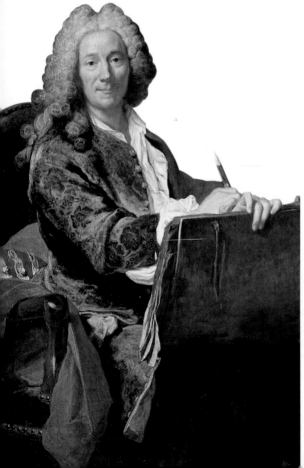

without further consultation, Jean Chardin registered his son with the Académie de Saint-Luc, a once-respected institution whose influence had waned by the time Chardin joined it. Only the Académie Royale de Peinture et de Sculpture, founded in 1648, carried weight in official circles.

Chardin's first contacts with contemporary artists date from his apprentice years. He is thought to have worked first for Noël-Nicolas Coypel (1690–1734), 'who needed a young man to help him with some work'. Cochin also records that in 1731 Chardin assisted with the restoration of a gallery at the Château de Fontainebleau,

This drawing of a male nude (below) betrays a still uncertain hand. Presumably the young Chardin did not think it important as he used the verso for a sketch of *The Vinaigrette* (1720–2; bottom). This sketch was used in turn for the right-hand side of his first composition, a surgeon's signboard commissioned by a surgeon friend of his father's. The engraving by Jules de Goncourt (top) is all that remains of Chardin's lost painting.

working with Jean-Baptiste Van Loo, elder brother of the famous Carle Van Loo. We know that at about this date the Galerie François I was restored, which was originally decorated in the 16th century by Francesco Primaticcio and Rosso Fiorentino.

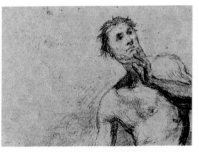

The first works by Chardin to have survived also date from this period. They are drawings, the only drawings by Chardin that exist and probably the last he made. One that represents the upper body of a male nude was presumably executed in Cazes's studio. It certainly bears some stylistic resemblance to the work of Chardin's first teacher, who, according to Cochin, 'painted his finest pictures purely from practice, using a small number of studies which he had made in his youth and figures which he had

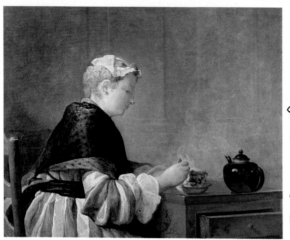

The marriage contract (above) between Chardin and his first wife Marguerite

drawn at the Académie'. This was the method he trained his pupils to adopt. Three other drawings by Chardin survive from these apprentice years. They are all preparatory studies for his first compositions.

An ordinary life

While still a student Chardin met Marguerite Saintard, the middle-class daughter of a family of tradesmen. On 6 May 1723 a marriage contract was drawn up and signed by the young couple. Chardin was twenty-four, with virtually no money, while Saintard had a large dowry. 'The marriage was put off until a later date,' Cochin records discreetly, without further explanation. The wedding finally took place on 1 February 1731, nearly eight years later. 'In the meantime the young woman's father's business collapsed, and it turned out that instead of the respectable fortune she had been led to expect she had nothing at all. However, M. Chardin was ruled by constancy and married her despite this set-back.'

In the same year Chardin experienced the death of his father and the birth of his first child, a son called Jean-Pierre. Two years later, he had a daughter Marguerite Agnès, who died young. Chardin's wife Marguerite

Saintard, shows the date – 6 May 1723 – and the signatures 'Chardin' and 'Saintard'. *Lady Taking Tea* (top left) probably shows Marguerite Saintard. It dates from two months before her death in 1735, and the model resembles that of *Lady Sealing a Letter* (see page 62). The teapot and table feature in an inventory of her possessions.

Saintard died in 1735, and he was left to live alone with his son. In 1744 he remarried. His second wife, Françoise Marguerite Pouget, was, according to Cochin, 'a kindly and honest widow. She was quite well off and this helped him greatly until the end of this life. Without her help, painting would not have given him a very comfortable living'. A daughter born of this second marriage died at an early age.

Chardin rue du four au coin de la rue princesse Faubourg Saint Germain il excelle aussy aux animaux aux choses naturelles et aux petits Sujets Naifs.

To judge by Cochin, Chardin's life was in no sense exceptional. There are no references to the artist's innermost soul and emotions. When Cochin mentions his friend's two marriages, he discusses only their financial implications. Not surprising perhaps, but still extremely uncommunicative on his part. Given Cochin's generally careful choice of words, it is impossible to ignore the distinctive phrase he uses to describe the circumstances of the painter's first marriage, that he 'was ruled by constancy'. Cochin expresses surprise, because he would not have regarded

Below: Chardin's second wife, Françoise Marguerite Pouget. Chardin lived during both his marriages in Saint-Germain-des-Près, until he was given his lodgings in the Louvre in 1757. It was during the reign of Louis XV that demolition began of the houses on the bridges of Paris, which blocked the light and hid the view. In this picture of the Pont Royal (left) no buildings remain and it is possible to see the boats that criss-crossed the Seine every day carrying goods between ports and ferrying passengers. To the left, the south facade of the Louvre is visible. The artists' studios were on the east facade.

FRA. MARG. POUGET.
Femme de M. Chardin, Peintre du Roy
Conseiller et Tresorier en son Academie

constancy as one of Chardin's main virtues. From this it
may be assumed that the artist truly loved his fiancée, or
at least was ready to settle down.

There was another event in Chardin's life that centred
on money, in Cochin's text. When Jean-Pierre Chardin
turned twenty-six, his father presented him with the
accounts for his guardianship and insisted his son
renounce part of his inheritance from his mother. In
a deed certified by a notary on 11 August 1757, Jean-
Pierre Chardin not only forfeited the right to much of
what was due to him from his mother's estate but also
relinquished any claim on her dowry. The argument
behind this, surprising though it now seems, was that
the total sum paid out by Chardin senior for his
maintenance and subsistence and cost of his studies
was much greater than the son could have hoped
to receive from his father's estate.

It is not clear exactly what lay behind this
request, but money was obviously of prime
importance to Chardin. And yet, although
there were times when funds were running
low, from various inventories drawn
up throughout his life it is apparent
that he was never truly in need. His
obsession with his finances betrays
the influence of his background.
In that sense Chardin was still
very much the son of a family of
bourgeois artisans, people who
knew the value of money.

Chardin the younger

As Cochin explains,
Chardin 'had hoped that
his son would achieve a
certain distinction as a
painter' and financed
the classical education
he himself was denied.
In 1754, at the age of
twenty-three, his son won
first prize in painting at

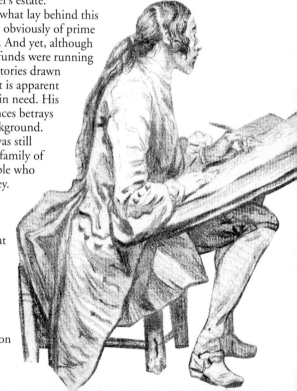

It was life drawing
sessions like this
(opposite) that Chardin's
son attended at the
Académie. He is shown
(below) concentrating
on his drawing of
the model.

the Académie. 'In truth,' Cochin relates, 'he won it too easily, as his painting was too weak. However, this was not unjust, because the competition was even weaker.' The son seems to have been a failure as a painter. He started paintings 'which held great promise', but never completed them. The traditional trip to Italy – he left Paris in 1757 – seemed not to bring about any great change in his style, and he did not even send work back from Rome as the painters were supposed to do.

By 1767 Jean-Pierre Chardin was thirty-six years old and had not painted a single masterpiece. He left Paris for Venice to stay with the French ambassador to the city

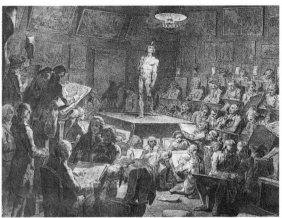

of the Doges, the Marquis de Paulmy. He never returned to Paris, but committed suicide in 1772 by throwing himself into a canal.

Chardin in society

Jean-Pierre Chardin's low opinion of himself may echo something in his father's character. In the *Salon* of 1765 Diderot wrote, 'Remember what Chardin said to us at the Salon: "Gentlemen, gentlemen, restrain yourselves. From all the paintings here, find the very worst; and then recall that two thousand wretches bit their brushes in two, despairing they would ever paint that badly."' It is

'Let me tell you, one day Chardin's son and some art students were examining a picture by Rubens. One said: "Just look at the way that arm is drawn." Another: "Do you call those fingers?" The former: "Where does that leg come from?" The latter: "See how he's done the collar." "What about you Chardin, nothing to say?" "Forgive me, what I have to say is that you must be bloody stupid to get your fun picking holes in masterpieces when there are bits in them that pass all understanding, enough to put you off brushes and palette for life."'
Diderot,
in a letter to the sculptor
Etienne Falconet

The anecdote related by Diderot illustrates Jean-Pierre Chardin's neurotic perfectionism. Where his friends enjoy remarking on the picture's supposed bad points, he can only view it as an outright masterpiece. While his response is in part ironic, the true object of his criticism is not his friends but himself. The subtext is his own inability to produce a masterpiece.

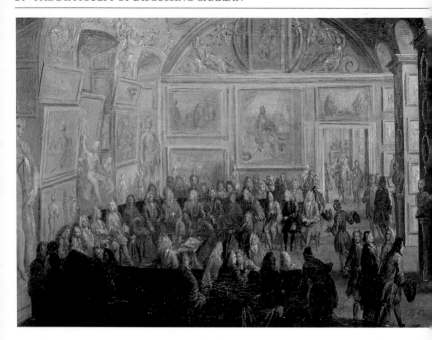

L'Académie a jugé à propos d'établir un ... Tré... Statuts ordonnés par le Roi le 24 Décembre 166... voix unanime pour remplir cette place, et l'a acce... des Statuts.

Chardin must have missed some of the Académie council sessions (above, Martin's *Assembly...at the Louvre*) in the forty-four years he was an officer, but his absence is recorded only twice: for six months in 1742 when he was ill, and in October 1779, two months before his death.

the father speaking, but is not the tolerance he requests the same exhibited by the son when he attacked his friends for being too ready to criticize a painting by Rubens? Chardin was sixty-six and had a long and successful career behind him when he spoke those words. Yet the restraint he urges, and the humility that implies, add up to a picture of someone still afflicted by

self-doubt, lacking the assurance supposed to accompany success.

It is known that he hated criticism, and Cochin described him as 'an extremely sensitive man. He was very grateful for the favours he received, but he was also very irritated by bureaucracy when he suffered under it. This manner which he had of being rather bitter at the end of his days, when he took a few disagreements a little too much to heart, was unfortunate'.

Chardin certainly was 'very grateful for the favours'. Late in his career, when Madame Adélaïde, the daughter of Louis XV, asked the price of a pastel by him she admired and wanted to buy, he was so conscious of the honour that he refused to name a price and made her a present of it instead. He also demonstrated his gratitude to the Académie by the remarkable regularity with which he attended its meetings, as the minutes record.

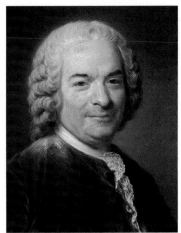

These meetings were held every month. Chardin began to attend them in 1730, well before he was appointed a council member, and continued until 1779, long after he had ceased to act as treasurer at the age of seventy-five. As well as holding the honorary rank of council member since 1743, he also performed a variety of more demanding functions: treasurer from 1755 to 1774, a position in which he demonstrated 'zeal and orderliness', and 'hanger' or *tapissier* at the Salon, responsible for hanging the works selected for exhibition.

The post of treasurer that Chardin (above, in a portrait by Quentin de la Tour of 1760) assumed in 1755 was provided for in the Académie statutes but had not previously been filled. Until then the caretaker had dealt with the accounts and he, according to Cochin, had been less than efficient. When Chardin was elected by a unanimous vote (left, an extract from the Académie registers), he found the place in a 'precarious financial situation because of the bankruptcy' of the said concierge, dead just 'a year after receiving the pension granted by the king'. However, thanks to Chardin, order was restored and 'everything was dealt with'.

Although this was a prestigious post because of the power it conferred, it placed the individual concerned in a delicate position. Chardin continually had to deal with people's wounded susceptibilities and impassioned pleas. Presumably it was his moderate and conciliatory nature that won him the job.

A private person

Chardin was conscientious and hardworking for the institution where he was welcomed and for those who placed their trust in him. However, while he enjoyed being appreciated for his qualities, he never lapsed into naked opportunism. Though he relished praise, Chardin was essentially a private person. He did not move in society, unlike Cochin who led a very active social life. Cochin's correspondence is continually occupied with

Chardin liked the theme of a boy building a house of cards and used it on four different occasions. This canvas (below) was exhibited at the Salon of 1741, and engraved by François Bernard Lépicié. In 1762 the print was distributed free to purchasers of the January issue of the *British Magazine*, accompanied by an anonymous article asserting that the work symbolized the vanity of human wishes.

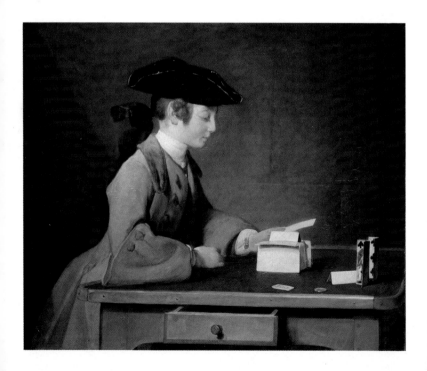

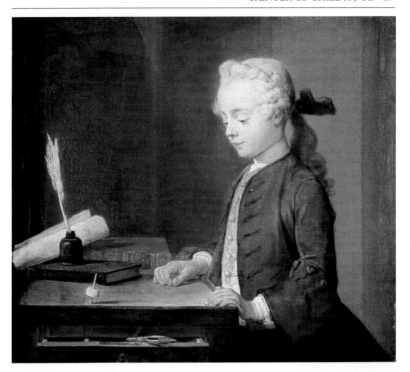

fashionable evenings and dinners in town, but not once is there a reference to his friend Chardin.

One of the few mentions of a dinner attended by Chardin appears in the diary of the engraver and dealer Pierre Alexandre Wille. On 12 February 1765 Chardin is said to have dined with Messieurs Papetier and Eberts, print dealers: 'The engravers Messieurs Flipart and Choffard, and the painters Messieurs Roslin and Vien were there with several others. We passed our time most pleasantly.'

Although Chardin knew many famous men during his career – Maurice Quentin de la Tour painted his portrait, Diderot was his great supporter – he never used any of them as models. Not even Cochin, to whom he owed so much. Yet he was perfectly happy to paint people from his circle. *Le Souffleur* represents his painter

Exhibited at the Salon of 1738, *Child with a Spinning Top* (above) was engraved by Lépicié. Beneath the print, which was published in the *Mercure de France*, the caption appeared: 'In the hands of Caprice to whom he abandons himself/ Man is a top which spins ceaselessly;/ Often his destiny depends on the motion/ Fortune imparts to it when she sets its spinning.'

and dealer friend Aved, *House of Cards* shows the son of Monsieur Le Noir, a Paris businessman, the *Child with a Spinning Top* is the son of Monsieur Godefroy the jeweller.

Does that not indicate that Chardin felt more at ease with people who were from the bourgeoisie, dealers and artisans like his own family, than he did with his colleagues and admirers?

Chardin never travelled abroad. Unlike most of the painters who had benefited from the classical training at the Académie, he did not make the traditional trip to Italy – surprising, given that his friend Cochin had been there and must have sung its praises, and his own son lived there for several years. In fact, Chardin appears never to have travelled even a short distance outside Paris.

While there are a great many drawings from life executed by Gabriel de Saint-Aubin in the course of his ramblings about the city, the drawings by him that were used to illustrate the catalogues of sales and exhibitions, which he sometimes took as the basis for a watercolour (detail of *The Salon of 1765*, below left), are a precious source of information for historians and critics. It is thanks to these

Nous finirons par remercier au no cho , M. *Chardin* de ce qu'il a bien vo

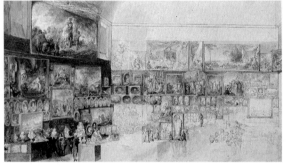

works that it is possible to know what a Salon hung by Chardin looked like. A most untypical figure in the artistic world of the 18th century, Gabriel de Saint-Aubin was the son of an embroiderer to the king. Having three times failed in the competition for the Grand Prix de Peinture, his relations with the Académie Royale were frosty, and he became one of the most ardent supporters of the Académie de Saint-Luc, where he also taught. Everyone in Paris knew Saint-Aubin, who was a tireless walker and a man of insatiable curiosity. He must at some time have met Chardin at the Salon.

Malice or mischief?

Chardin's need for approval may have made him particularly conscientious in his professional dealings with people who respected him, but it also made him wary of competitors. In 1761, the year Chardin was put in charge of hanging the Salon, Jacques-Charles Oudry, son of the famous animal painter and a painter himself, wrote an insulting letter complaining about the position

he had been allotted. Oudry found himself barred from the Académie's assemblies until he made amends to Chardin, the object of his attack, and to the Académie itself. The two paintings he had on show at the Salon were removed before the closing date. This suggests that even if Chardin enjoyed considerable influence among his academician colleagues, he was not held in the same esteem by his fellow painters.

u Public , dont nous ne fommes que l'é-
fe charger de l'arrangement du Sallon.

On more than one occasion Diderot describes Chardin's malice in his arrangement of the pictures, sometimes to his own advantage. We learn that he 'had no hesitation in putting himself next to two of the finest Vernets' (although it must be noted in passing that Joseph Vernet, while of course very famous, painted seascapes, subjects that bore no relation to Chardin's pictures and could not provoke comparisons). Diderot also recounts other episodes he regards as even less flattering. On one occasion Chardin relegated a Boizot and a Millet to an obscure corner, another time he put himself next to Challe: 'M. Chardin, it is not done to play such tricks on a colleague: you do not need such foils to advance yourself.'

How are we to interpret these acts of calculated mischief in Chardin's later life except as a fear of not being sufficiently appreciated? His origins did not destine him to become an Académie member. He still saw

In 1765 Chardin showed eight pictures at the Salon (above), among them *The Attributes of the Sciences*, *The Attributes of the Arts* and *The Attributes of Music*, all three destined for the Château de Choisy, one of Louis XV's favourite residences. Also on display were a *Basket of Grapes* and a *Basket of Plums with Nuts*…. In the 18th-century manner, the paintings were hung so close that they touched each other. Diderot notes in his account of the Salon: 'There is hardly anything to choose between them. They are all equally perfect.'

Autant que la forme des tableaux a pu le lui permettre , il les a diftribués non feulement de manière qu'ils ne fe puffent nuire les uns aux autres , mais de forte que la plupart fe fiffent valoir l'un l'autre

himself very much as the faithful servant of the institution, conscientiously carrying out duties others might regard as beneath their dignity, so is it surprising he applied the same determination to maintaining his position as one of the great painters of his day, even at the price of a few underhand acts?

A solitary pursuit

Though he enjoyed his long and enthusiastic discussions about painting with Diderot, Chardin remained reticent in public. He was also secretive in the pursuit of his art. Diderot notes in his account of the Salon of 1767: 'It is

In *The Morning Toilet* (1741; below right) the clock in the right corner shows a few minutes before seven, the time for mass. The mother's missal and muff lie on a stool, the candle has just been blown out, and a wisp of smoke still rises from it. The mother adjusts her daughter's bonnet, while the girl watches the

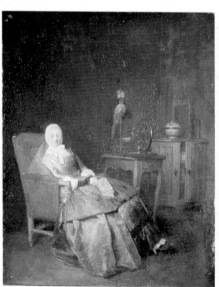
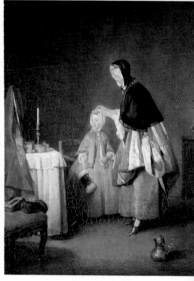

said that Chardin has a technique all of his own and that he uses his thumb as much as his brush. I do not know what it is; what is certain is that I have never known anyone who has actually seen him paint.'

Chardin worked alone. He seems to have had no pupils, except possibly someone to mix his colours. His studio was not a busy place. The only recorded visit was made in 1741 by 'Mehemet Effendi, also known

finishing touches being put to her outfit in the mirror on the dressing table. The poses of the models and the meticulous rendering of the clothes help to make the picture one of the most elegant Chardin ever painted.

as Said Pacha, Berglierbey de Roumely', ambassador extraordinary to the Sultan on his visit to Paris. It is not known what paintings he saw, possibly *Child with a Spinning Top*, which dates from 1737. Chardin was very susceptible to honours of this sort, and would probably have prepared his studio for the visit, but otherwise it is likely that an unannounced visitor would have found it almost empty. Chardin's output was not large. He was a regular exhibitor at the Salon, but often showed only a few pictures at a time, and not always the most recent. In 1751 Coypel writes of the Salon that 'the public are annoyed at only ever seeing one picture by such a skilled hand. I did hear he was presently working on another one, the unusual subject of which intrigued me. In it he paints himself with a canvas stood before him on an easel, a small Genius representing Nature brings him his brushes, which he takes, but at the same time Fortune removes some of them from him and, as he contemplates Sloth who smiles at him with an indolent air, the remaining one drops from his hand!'

Slow progress

No such painting exists, so presumably the author was joking. However, he was not alone in criticizing the painter for his slowness. The critic La Font de Saint-Yenne even cast doubt on the artist's ambition, saying he painted 'just for his own amusement and consequently not much at all'.

Collectors also had good reason to complain of the painter's slowness to deliver. In 1745 Chardin was commissioned to produce two works for Louisa Ulrica, Princess Royal of Sweden. Count Carl Gustaf Tessin, the

During his ambassadorship Carl Gustaf Tessin (below) commissioned *The Morning Toilet* (opposite right) from Chardin. In 1745 Louisa Ulrica commissioned two more pictures on the themes of 'a strict upbringing' and 'a gentle and lenient upbringing'. The painter did not follow instructions and treated two entirely different subjects, one being *The Amusements of Private Life* (1746; opposite left).

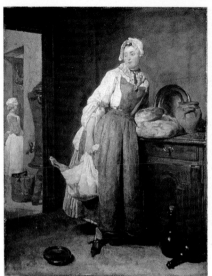 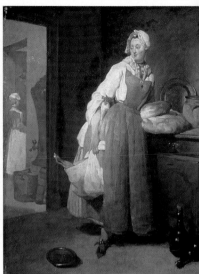

future Queen of Sweden's ambassador in France, sent back his report: 'The exhibition of paintings at the Louvre is very extensive this year. Your Excellency will find a list attached. It will confirm [François] Boucher's laziness and Chardin's slowness.'

It was not until two years later that Tessin had news: 'Chardin, who although slow does at least finish what he has started, has just delivered to me the second of the two pictures that were commissioned two years ago.'

The artist's slowness also limited the number of works he painted to less than three hundred, the majority of which have survived, while the rest are known from engravings and photographs or simply from references. It is a relatively low total, given Chardin's exceptionally long career of nearly sixty years, and even less impressive when it is understood that it includes a large number of replicas, sometimes as many as five of the same subject. Approximately one third of Chardin's total output is made up of these replicas, reducing the number of

Although the contemporary press complained of Chardin's 'laziness', the term seems unjust, or at least harsh. Even Mariette, who did not really like Chardin's work, referred to his slowness rather than his laziness, something he explained by the absence of preparatory drawings, which obliged Chardin to keep what he was painting in front of his eyes 'from the first sketch until he had made the final brushstrokes'.

original subjects to some two hundred. What is more, these subjects belong to only three genres: still lifes; genre scenes; and portraits. There are no landscapes, no historical or mythological subjects, no religious scenes.

Chardin offered the following excuse to Tessin's correspondent, Carl Frederick Scheffer: 'I am taking my time because I have made a habit of not leaving go my work until, to my eyes, it requires nothing further.' Diderot expands on the theme: 'Chardin is such a rigorous imitator of nature, such a severe critic of himself, that I have seen one of his paintings of game that he never finished because the little rabbits he was copying had rotted away, and he despaired of achieving the harmony he had in mind if he used any others.'

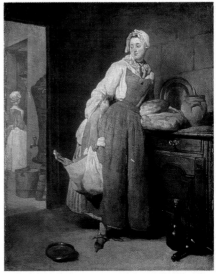

Chardin was a slow painter. It is possible to assume this failing was because he took a long time arranging the objects he wanted to paint and examining them in different lighting. Yet any study of the development of composition in his canvases provides striking evidence of the similarities between the various works, to the point that some paintings appear actually to be variants of one another. As well as replicas there are variants, or variations on a theme, something that surely betrays a distinct lack of imagination on the painter's part. Besides, he opted for those genres in which invention mattered less than observation. He did this presumably out of natural inclination but also from

There are three known versions of *Girl Returning from the Market*, dating from 1738 to 1739. A fourth was destroyed during the Second World War. The sketch (bottom left) appears in the Salon catalogue for 1769. The work attracted much praise, notably from the Goncourt brothers: 'From the lovely tender pale tones that are scattered about and echoed everywhere, even in the white of the blouse, a dappled grey mist arose like creeping daylight – a hot dust, a suspended vapour enveloping this woman, her whole costume, the buffet, the loaves on the buffet, the wall, the room at the back.'

fear, the fear of the self-taught man who secretly doubts his own ability. Everything Chardin knew, he knew because of his work. The mastery he had achieved was founded on careful observation and determination. Chardin simply would not have believed himself capable of tackling the great themes of the imagination – religious and historical subjects, for example – which he regarded as the preserve of painters trained by the Académie.

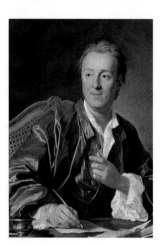

Is Chardin a realist painter?

Chardin cannot be called a realist painter, at least not in the 19th-century sense of the word, as he had no interest in depicting the social reality of the world about him. His works offer no message. Unlike the pictures of Jean-Baptiste Greuze, for example, they are not primarily intended to convey either meaning or narrative – a fact that is true not only of the still lifes but also of the genre scenes representing the typical interiors of the respectable bourgeoisie, which seem as though they are frozen in time, and mute.

If Chardin is a realist, it is in the actual practice of his art, and almost by default. It is because he avoided the most prestigious genres, and because he lacked imagination, that he concentrated on the reality before his eyes. Diderot makes this point in the *Salon* of 1769: 'Admiration for what is good stays with me. Chardin is not a history painter, but he is a great man…. Take your time in front of…a beautiful Chardin; absorb the effect into your mind; then relate everything which you see to this subject and rest assured that you have found the secret of rare satisfaction.'

This portrait of Denis Diderot (left), Chardin's great champion, is by Louis-Michel Van Loo, painter of numerous portraits of his contemporaries. It was shown at the Salon of 1767. The sitter, then fifty-four, wrote a humorous response: 'His grey quiff is so affected it makes him look like an old trollop still putting on airs…. But whatever will my grandchildren say when they compare my sad works with this cheerful, dapper, effeminate little old fellow! My children, I promise you, it is not me.'

This *Dead Hare with Gamebag and Powder Flask* (opposite) is one of Chardin's most striking compositions. It dates from the early part of his career, from c. 1726 to 1730. The nail from which the creature is suspended, the spread paws, the strap of the gamebag slicing across the body of the hare, the head left hanging in space – all give the painting a surprisingly violent air, possibly revealing a side of Chardin's character normally kept hidden.

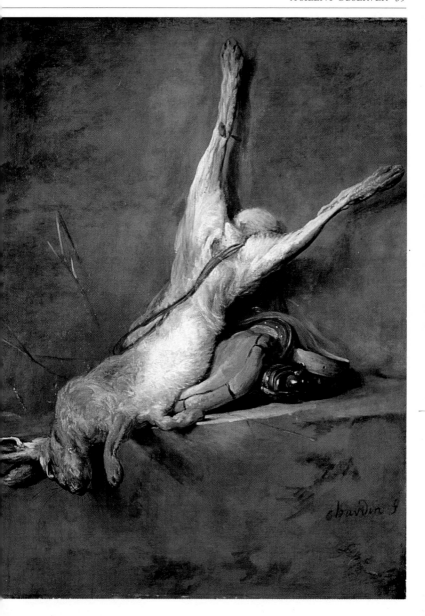

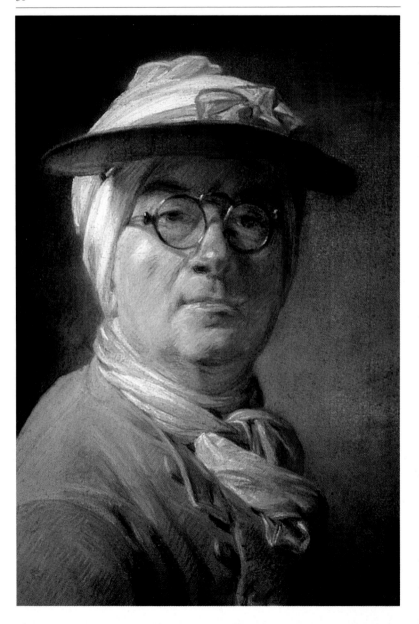

Chardin had not had the classical education required to enter the Académie Royale de Peinture et de Sculpture that would have given him the right to exhibit at the Salon, which was patronized by the king, the nobility and the major collectors. He was, however, admitted to this prestigious institution on 25 September 1728 by a special procedure.

CHAPTER 2

CHARDIN AND HIS AGE

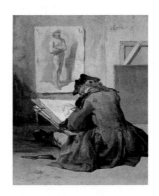

A young man (right) leans over his portfolio to copy a study of a male nude in red chalk pinned to the wall; though his face is hidden, such is the painter's skill in *The Draughtsman* that the man's concentration is at once apparent. It is known that Chardin (*Self-portrait with Eyeshade*, 1775; opposite) found drawing hard.

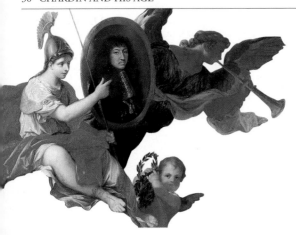

In his *Allegory of the Foundation of the Académie Royale de Peinture et de Sculpture* (detail, left), Nicolas Loir pays tribute to Louis XIV, who sanctioned its foundation. Minerva, accompanied by Fame and Love of Virtue, points at the king's image. The artist submitted the painting as his reception piece at the Académie on 2 October 1666. By recalling the sovereign's role in the establishment of the Académie Royale, the work acts as a salutary reminder of the links between art and the state. Although Chardin received some public commissions late in his career, he was for the most part excluded from this whole aspect of official art.

Saint-Luc versus the king

In the 18th century French artistic life was highly regimented. The Académie Royale reigned supreme and practically unchallenged, making it difficult for any painter to pursue a successful career outside it. When the institution was founded in 1648 by Louis XIV's minister Jean-Baptiste Colbert, it marked the decline of the corporation system that, ever since the Middle Ages, had controlled the careers of the artisan painters, who received their education from masters to whom they were apprenticed by the guild. On completion of their apprenticeship they had to present their 'masterpiece' to demonstrate they had learned the rules of their art. Only then were they entitled to receive the mastership of their corporation and become masters in their turn. The system enjoyed the backing of Parliament and the legislature. Effectively it was a monopoly because only master painters could practise their profession in France.

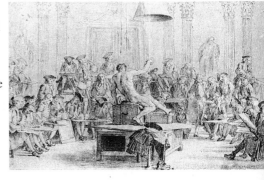

Inspired by texts from antiquity, the Renaissance had revived the ancient opposition between the liberal arts, for the exercise of creative genius, and the mechanical arts, for the practice of craft skills. Many artists in subsequent generations believed painting should revert to its former status as a liberal art, and be freed from the control of the corporation, which treated it essentially as a craft. With this in mind, in the first decades of the 17th century a proposal was put to the king to found an Académie in Paris based on the Italian *accademia*, derived in their turn from the famous Greek Academy where Plato taught. The artists' initiative, rooted in the myth of reviving the Golden Age of painting, was rewarded in 1648 by the foundation of the Académie Royale de Peinture et de Sculpture. It comprised twelve artists who had given proof of their skills, and included a school offering lessons in life drawing. By its statutes, members were excused from the need to qualify as masters.

The corporation attempted to fight a decision that meant its own downfall. In 1649 it was inspired by the French painter Simon Vouet (1590–1650) to open its own school, the Académie de Saint-Luc. Vouet was its presiding genius. The corporation hoped in this way to restore its fortunes: its long history guaranteed its standing in the eyes of the world and the eminence of its director confirmed the excellence of the teaching. Indeed, according to contemporary sources, the Académie Royale retained no more than 'a very small number of students' and was reduced to a state of decline 'approaching total collapse'. However, the success of the Académie de Saint-Luc was shortlived. Vouet became involved in other activities and had little time to devote to it. His death in 1650 deprived the institution of much

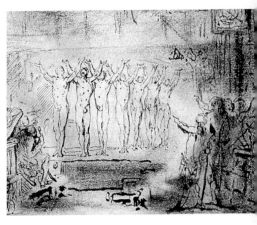

With the caption 'The models tried out by ourselves, the officers of the Académie, on the afternoon of 10 August 1774', this drawing by Gabriel de Saint-Aubin (below) is a rare representation of the teaching studio at the Académie de Saint-Luc. Seven nude males stand on a dais under the lamplight, with their arms raised. The use of life drawing as a method of education was in direct competition with the teaching provided by the Académie Royale (opposite bottom), which is why the right to teach was soon afterwards withdrawn from the Académie de Saint-Luc.

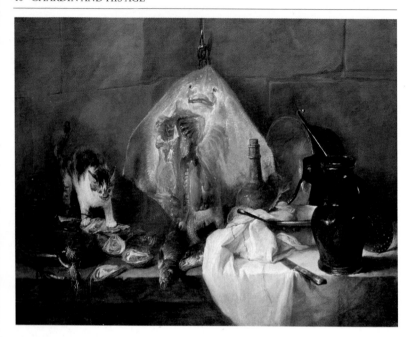

of the reflected glory of his reputation. Furthermore, in 1654 the Académie Royale obtained a royal warrant granting it a teaching monopoly. The corporation was relegated to a subsidiary position. It survived until the 18th century and trained a number of artists, of whom Chardin was the most distinguished. However, he resigned his mastership shortly after being accepted into the Académie Royale, and the Académie de Saint-Luc gained little benefit from the fact that he was a former member.

Chardin was in a difficult position with regard to the Académie Royale. Not only had he not been educated there, but he was already associated with an institution regarded as a relic of a previous age. Yet membership of the Académie was crucially important as it conferred the right to exhibit at the Salon. The status of academician was much more than an honorary title, it was the essential precondition for achieving public recognition.

The Skate (c. 1725–6; above) is one of Chardin's most famous compositions. It was probably not new when Chardin showed it in 1728 at the Place Dauphine (opposite). The painting exhibits a raw, powerful realism in its treatment of the grimacing 'face' of the bleeding fish.

The Salon de la Jeunesse

This event was the only officially sanctioned public exhibition apart from the Salon. It was usually held on the morning of Corpus Christi (the first Sunday in June) 'from six o'clock until midday', extending along the Pont Neuf and into the Place Dauphine. Although the pictures were displayed without ceremony and with numerous other heterogeneous objects, the Salon de la Jeunesse attracted large numbers of collectors. When the event was cancelled because of bad weather, there were so many complaints that it was held the following week. It was also much appreciated by the artists, and even by a number of academicians – among them Nicolas Lancret, François Lemoyne, Jean-Baptiste Oudry, Noël-Nicolas Coypel and François Boucher – who were happy to exhibit there when the Salon was suspended from 1727 to 1737. Chardin participated for the first time in 1728

The exhibition at the Place Dauphine was held in the northern corner of the square, on the route of the Saint-Barthélemy procession. It is pictured here in the year 1780 (below). To enliven the surroundings, the police required the paintings to be mounted on wall hangings (visible at the back).

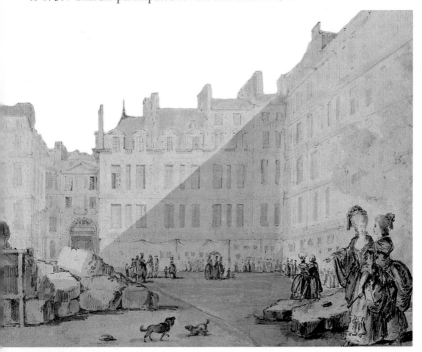

and his works, particularly *The Skate* and *The Buffet*, aroused huge interest.

Encouraged by this success and eager for recognition, Chardin determined, less than four months after the exhibition in the Place Dauphine, to join the Académie Royale. He was careful first to sound out one of the leading members of the Académie. Cochin tells us the ploy Chardin used to achieve his ends: 'He arranged the paintings he intended to submit in one of the first rooms, apparently haphazardly, and went into the next room. De Largillierre, an excellent painter and one of the finest colourists and the leading theoretician on the effects of light, went to see him. He paused to look at the pictures before entering the room where Chardin was. On entering, he remarked, "You have some very good paintings there. They are surely the work of some good Flemish painter.... Now let us see your works." "You have just seen them," replied Chardin....' Largillierre remarked: 'Present yourself with confidence.' Chardin did so on 25 September 1728. He was accepted and received on the

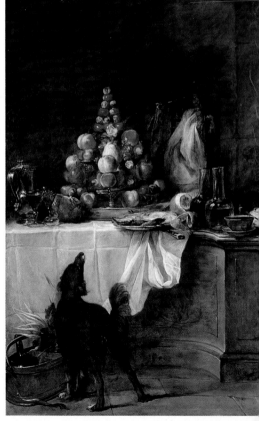

Receptions
de Peintres
à L'Académie.

Le S. Chardin Peintre d'Animaux, de
Batterie de Cuisine et de différentes Légumes.

The *Buffet* (opposite) dates from 1728. This painting and *The Skate* were selected by the Académie as Chardin's reception pieces (document, left). More classical and more restrained, *The Buffet* was probably chosen to counterbalance the 'expressionist' excesses of

same day. The Académie chose as his reception pieces *The Skate* and *The Buffet*, previously shown at the Salon de la Jeunesse, where he exhibited in 1732 and 1734 *The Washerwoman, Woman Drawing Water from a Copper Cistern* and *House of Cards* for the first time. After 1737 Chardin showed his work only at the Salon organized by the Académie.

The Salon

The Salon acted as a sort of shop window for the work produced in the Académie. Its primary function was to demonstrate through public exhibitions of members' work the excellence of the teaching on offer and the quality of the artists educated there, in that way justifying the privilege granted to academicians that absolved them of the requirement to qualify as masters.

After an interval of ten years because of administrative problems, the Salon resumed in 1737. At first it was held once a year (except in 1744), and, from 1748 onwards, every two years. It began on 25 August, the king's feast day – he was a regular visitor – and lasted a month. It was held at the Louvre in the Salon Carré, from which it took its name. In exceptionally busy years it sometimes spread over into the Galerie d'Apollon. The Salon rapidly became the major event in French artistic life.

The Skate. Although details like the half-peeled lemon evoke Flemish painting, the work is more in the French tradition of buffet paintings by Alexandre-François Desportes (1661–1743). In 1860 Vermeer's champion Thoré recalls the astonishment that greeted the work: 'Who in France at that time could have painted this magnificent picture?'

The *Buffet* was not as successful as *The Skate*, but was often studied by other artists. In the 19th century Philippe Rousseau 'spent many dejected hours under the spell of this picture, despairing already of the lack of success of any imitations of it'. Henri Matisse also made a copy of *The Buffet.*

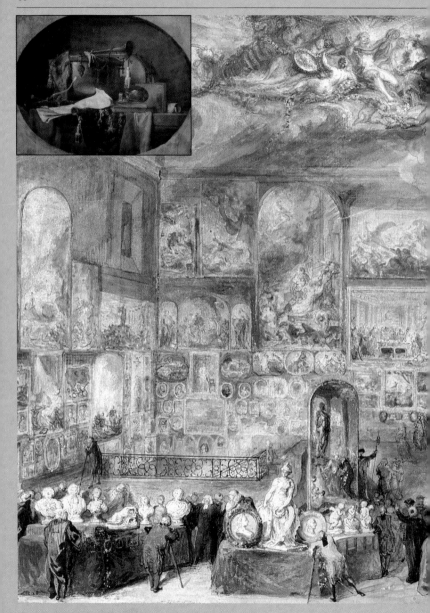

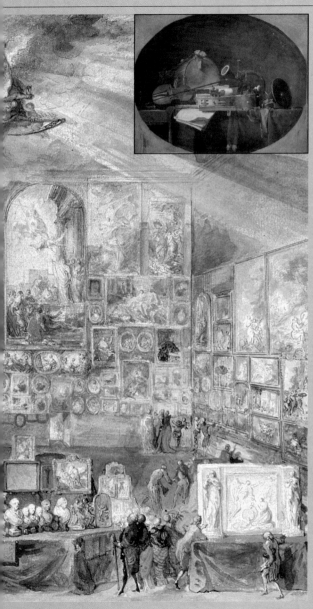

At the Salon of 1767, pictured here by Saint-Aubin (centre), Chardin shows 'number 38: two pictures under the same number representing various musical instruments'. *The Attributes of Battle Music* (opposite top) and *The Attributes of Civil Music* (left) were two paintings commissioned by the king for the Château de Bellevue. Saint-Aubin's watercolour shows how the pictures of the academicians were displayed in close proximity. Chardin oversaw the hanging. In the middle of the room are tables covered with sculptures, with a bas-relief to the right, and easel paintings.

The Salon achieved increasing popularity with the public during the 18th century. The figures speak for themselves: in 1755, 8000 *livrets* were sold (the *livret* was a printed list of the works on display), rising to 20,000 by 1783. The number of visitors in 1763 was around 700 to 800 a day. There was little variation in the number of exhibitors – between 60 and 80 – but the number of works exhibited was constantly increasing, from 250 to around 500 by the end of Louis XV's reign.

C'est avec plaisir que nous annonçons
elle est grande comme le Tableau original

Public recognition

As a member of the Académie, Chardin enjoyed a higher status and his career began to flourish. In 1730 he was commissioned to execute three overdoors representing 'music and instruments' for the Comte Conrad Alexandre de Rothenbourg, an exotic figure who ended his career as French ambassador in Madrid. He was also the purchaser of the *Portrait of the Painter Joseph Aved* (also known as *Le Souffleur*, *The Chemist* and *The Philosopher*), which Chardin recovered from the Rothenbourg estate in 1735, as he had apparently never been paid for the painting. However, it was from 1737 onwards, when the Salon resumed its activities, that the painter really began to achieve public recognition. In that year he submitted seven pictures. The following year saw the appearance of the first engraving based on one of his works, the *Lady Sealing a Letter* by Etienne Fessard, followed in the same year by two engravings by Cochin senior, *The Little Soldier* and *Little Girl with Cherries*, after paintings exhibited at the Salon of 1737. Engravings of Chardin's works proliferated and achieved immense popularity, as the collector and print dealer Pierre-Jean Mariette notes: 'The prints engraved after works by Chardin were no less successful; they became

L *ady Sealing a Letter* (detail, above left) was painted around 1733. The engraving (opposite and detail above right) was made in or shortly before 1738 by Etienne Fessard, and accompanied by the caption (opposite): 'So hurry up, Frontain; look at your young mistress,/ Her tender impatience shines in her eyes;/ She already longs for the object of her wishes/ To have this letter, proof of her tender feeling./ Ah! Frontain, if you act so slowly/ The god of love has never touched your heart.' The caption treats the work as a romantic interlude, revealing the public taste for this type of picture.

ujourd'hui le débit d'une Eſtampe
ue le public a fort admiré dans le dernier ſalon

all the fashion, and along with the prints of Teniers, Wouwerman and Lancret dealt the final blow to the serious prints of the Le Bruns, the Poussins, the Le Sueurs and even the Coypels of this world.'

Esteemed by artists

Chardin's pictures also sold well. Many of the buyers were artists, indicating the extent of Chardin's reputation among his colleagues. The painters included Joseph Aved, who at the time of his death was the

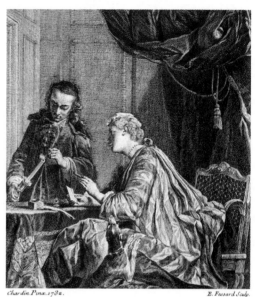

Chardin Pinx. 1732. E. Fessard Sculp.

Hâte toy donc, Frontain : vois ta jeune Maît.ᵉ, Ait reçu ce Billet, gage de sa tendresse.
Sa tendre impatience éclate dans ses yeux ; Ah ! Frontain, pour agir avec cette lenteur
Il lui tarde déjà que l'objet de ses Vœux Jamais le Dieu d'Amour n'a donc touché ton cœur

Paris chez Fessard Rué S.ᵗ Denis au grand S.ᵗ Louis, chez un Miroitier prés le Sepulchre, C.P.R.

owner of nine still lifes by his friend, also Louis-Joseph Le Lorrain, and Jean-Baptiste Van Loo, who in 1732 purchased at the Salon de Jeunesse a grisaille painted by Chardin after a bas-relief by François Duquesnoy. There were engravers like Jacques-Augustin Sylvestre, who regularly loaned his Chardins to the Salon (he owned sixteen at his death), Jacques-Philippe Le Bas, who engraved four scenes by Chardin, and sculptors such as Edmé Bouchardon, Robert Le Lorrain, François

For many years *Lady Sealing a Letter* was known only from the engraving by Etienne Fessard. It was not until about 1883 that the painting was discovered in Berlin behind a cupboard in the furniture store of the old Potsdam palace.

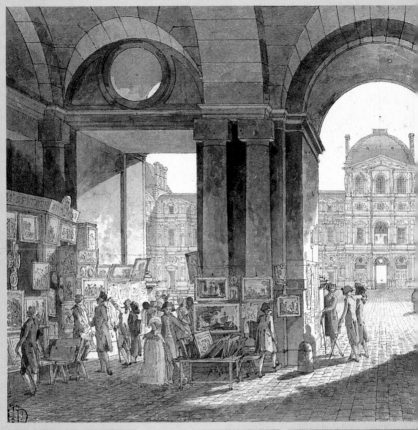

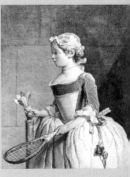

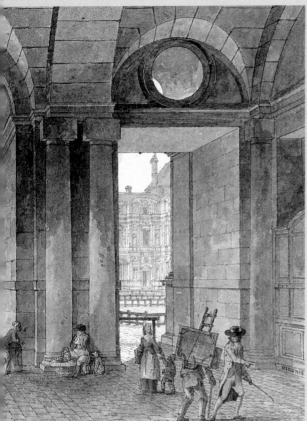

Engraving was to the 18th century what photography was to the 20th: an easy method of reproduction and a good way of creating a wider audience for works of art. Print dealers proliferated in the capital (a view of the gateway of the Louvre by Philippe Meunier; left). Chardin's genre scenes were often made into engravings (below and above), adding greatly to his popular reputation. Mariette notes with a certain scorn: 'The general public takes pleasure in seeing repeated the actions that take place in their homes every day right under their noses.'

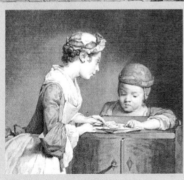

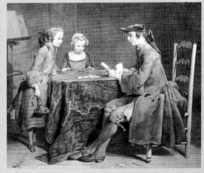

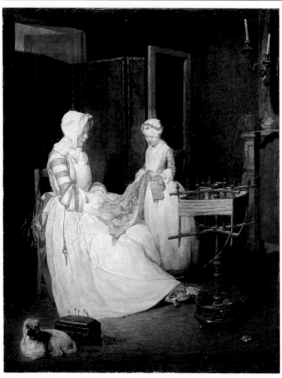

In *The Diligent Mother* (1740; left) a mother and daughter look at a piece of embroidery together. No exchange of looks, no gestures take place. Yet the accuracy of the characters' poses, the girl's docility as she stands before her seated mother, who is self-contained and attentive, are all it takes to convey the emotional relationship between the two.

Two years after his nomination as treasurer of the Académie and *tapissier* to the Salon, Chardin was given

Brevet

aux gallcoica

Du. 27. May 175.

Lemoyne and Jean-Baptiste Pigalle, who at the time of his death owned six Chardins. (The painter reciprocated by including Pigalle's *Mercury* in several of his own pictures.)

There was also a draughtsman called Aignan Thomas Desfriches, architects such as Pierre Boscry and Louis-François Trouard, who owned respectively ten and seven Chardins, and even a musician, Francesco Geminiani, an Italian violinist and composer who lived in Paris from 1749 to 1755.

The praise of princes

Even more encouraging was the fact that Chardin, although exclusively a Parisian painter, enjoyed a reputation abroad. His first commission came from the

rooms in the Louvre galleries. Official confirmation arrived with a letter from Marigny dated 13 March 1757. Above: detail of Royal Warrant. Cochin relates that the painter was deeply appreciative of the honour, which was a major advance in his career. It was probably a reward for services to the Académie.

Comte de Rothenbourg. He was also employed by Louisa Ulrica, future Queen of Sweden, who assembled an exceptional collection of Chardins in her castle at Drottningholm, some acquired from Count Tessin. There was also Prince Joseph Wenzel von Liechtenstein, Austrian ambassador in Paris, who bought four Chardins, Caroline Louise, Margravine of Baden, who purchased five, and Catherine the Great of Russia who in 1766 commissioned *The Attributes of the Arts and Their Rewards* for the Academy of Arts in St Petersburg, and also bought a number of his other pictures.

Louis XV himself owned several Chardins. The painter was presented to him at Versailles in 1740, and gave him two of his pictures as gifts: *The Diligent Mother* and *Saying Grace*. Chardin was also commissioned by the king to paint *The Bird Organ* in 1751 and several overdoors for royal residences: three for the Château de Choisy in 1764 and, two years later, two for the Château de Bellevue. After Chardin joined the Académie he achieved widespread fame. His work was appreciated not only in France but also abroad, by artists, kings and queens. This rapid rise brought substantial financial gains.

In 1730, each of the overdoors he painted for the Comte de Rothenbourg earned him 120 livres. Twenty years later the companion piece to *The Amusements of Private Life* was valued at 1500 livres. At the same time the allowance Chardin received from the Académie rose from 500 livres in 1752 to 1200 livres at the end of his career, a sum that made him one of the best-paid artists of his age.

Yet Chardin, who was not content with the fame he already enjoyed, also carried out a number of honorary duties at the Académie Royale, serving in succession as council member, treasurer and official *tapissier* at the Salon. This ambition may appear surprising for such a successful artist.

The Attributes of the Arts (below) was exhibited at the Salon of 1765, with *The Attributes of Music* and *The Attributes of the Sciences* (now lost). The three works were overdoors commissioned in 1763 for the reception room of the Château de Choisy. Sculpture and the goldsmith's art occupy a prominent position, alongside painting, drawing, architecture, engraving and medalmaking. The goldsmith's art is symbolized by the imposing ewer on the right. Sculpture is represented by the plaster cast of *The City of Paris* by Edmé Bouchardon – the original, made for the fountain at the Rue de Grenelle, was regarded by Diderot as the outstanding masterpiece of the sculptor. Chardin's choice was no doubt a tribute to the sculptor, who had recently died.

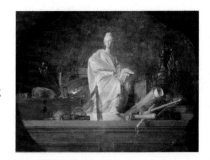

Catherine the Great was an admirer of Chardin's painting. When *The Attributes of the Arts and Their Rewards* (1766; right), commissioned for the meeting room of the Academy of Arts in St Petersburg, arrived in Russia, she decided to keep it for her personal collection. On her death, the empress of Russia possessed five Chardin canvases.

As in *The Attributes of the Arts* commissioned for the Château de Choisy (previous page), sculpture takes pride of place, symbolized this time by Pigalle's *Mercury*, which Chardin had already used in *The Drawing Lesson*, and of which he owned a cast. In 1762, when Pigalle was ill, Chardin was one of the painters sent by the Académie to visit his sickbed. Diderot, who cannot have been unaware of the commission from Catherine the Great, pronounced the *Mercury* rather too thin and 'too dominating the rest'. Despite that criticism, he still concluded in the *Salon* of 1769: 'Chardin is an old magician from whom age has not yet taken away the wand.'

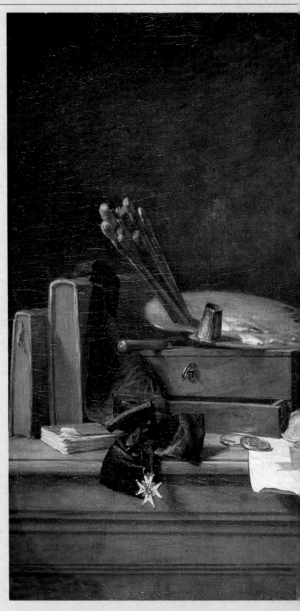

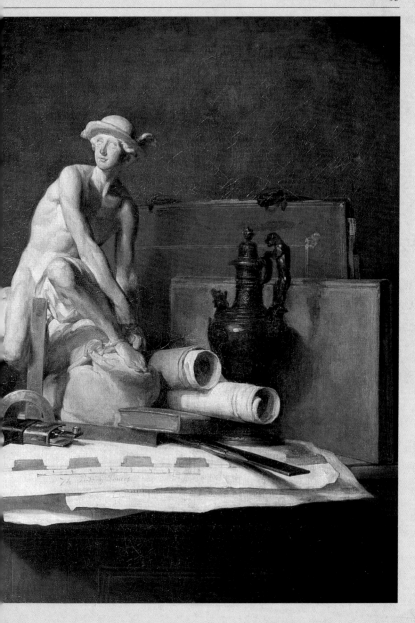

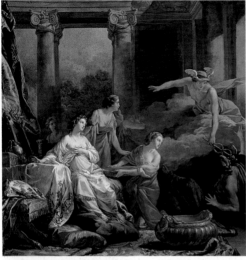

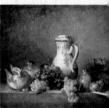

At least part of the explanation for it lies in the discrimination imposed by the hierarchy of genres.

From the major to the minor

In the 18th century the hierarchy of genres was universally accepted. It made fundamental distinctions between works of art based not on artistic quality but on subject matter.

According to the classification then current, history occupied first place and constituted the major genre. To this category belonged all works of art with themes drawn from religious or ancient history (modern history, which began in the Middle Ages, did not make its

Above: from top to bottom and left to right, five paintings classified according to the hierarchy of genres: *Mercury in Love with Herse changes Aglauros to Stone...* by Jean-Baptiste Marie Pierre (history); *The Painter Louis-Michel Van Loo and his Sister* by Louis-Michel Van Loo (portrait); *The Paralytic* by Greuze (genre scene); *Evening* by Joseph Vernet (landscape); and *Grapes and Pomegranates* by Chardin (still life).

appearance until the reign of Louis XVI). In second place came portraiture, followed by genre scenes and finally still life and landscape.

Nowadays such distinctions seem strange, but in the 18th century they were fundamental. In the document drawn up by André Félibien (1619–95), secretary and theoretician of the Académie Royale in the 17th century, the hierarchy of genres was the means of justifying to the corporation the creation of an academic elite.

It was reasoned that, because painting was an ambitious art, not content merely to reproduce objects mechanically, the ability to convey the life of human beings was superior to the simple imitation of inanimate objects or landscapes. This idea was clearly derived from the Christian doctrine according to which human beings were at the centre of the universe, God's finest creation, and therefore superior to rabbits, apples or trees. Because painting was also one of the noble arts, with a duty to instruct and offer religious or ethical 'examples', the subjects most worthy of consideration were the great acts of history that shaped human destiny.

While this definition of the painter's function owes much to the growing strength of humanism at that time, it also demonstrates that the pictorial arts were seen as subordinate to literature. History enjoyed prime position because its subjects were based on written sources. The way for a painter to excel was by 'representing' and glorifying the great religious, historical and mythological texts that made up the culture of letters. 'Read both the story and the picture, to make sure everything is appropriate to the subject,' recommended Poussin, confirming the primacy of the text.

For painters, the main implication was that their merit would be judged not on purely pictorial criteria but on the way in which their paintings conformed to external models that

The artists accepted by the Académie had to submit their reception pieces within six months in order to be received into the institution. Unlike Chardin, who was accepted and received the same day, Greuze was accepted in 1755 as a genre painter, but allowed twelve years to elapse without taking action. On being barred from the Salon of 1767, he chose a historical (and not genre) subject as his reception piece, based on the obscure theme of the attempted assassination of the Roman emperor Lucius Septimus Severus by his son Caracalla in AD 210 (below). The Académie criticized the lack of expression in his figures and the static nature of the scene and received him only as a genre painter. Humiliated by this rejection, he never again exhibited at the Salon. The incident reveals the privilege attached to the title of history painter and the strictness with which the Académie guarded its exclusivity.

they were required to understand, represent and express correctly. The most indispensable quality for artists was now the imagination, which was also called invention, as it was the only thing that would enable them to paint episodes they had not experienced for themselves, but which existed in stories. Chardin did not find invention easy, as the many replicas in his work attest. He started his career 'persuaded that the painter should take everything from his head and that you needed nature only when you lacked genius'. Certainly, judging from the few drawings that exist by the young Chardin, and that include a number of figures, the artist's early ambition was directed towards genre painting and perhaps, looking beyond that, to history painting itself.

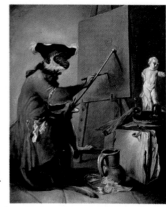

Reminiscent of Teniers, who popularized this type of caricature, and Watteau, who also indulged in 'monkey business', this *Monkey as Painter* (above) shows an 'artist' copying a mutilated putto that bears a strange resemblance to one painted by Cézanne.

Chardin and the 'minor genre'

According to Cochin, working with Noël-Nicolas Coypel was both a revelation and a decisive experience for Chardin: 'The first thing Coypel gave him to paint was the gun in the portrait of a man dressed as a hunter. Coypel took care to position the gun carefully and to light it just as it needed to be in his picture. He asked Chardin to paint it exactly. The latter was astonished to see such precautions taken, as he had never previously seen them applied so strictly.... However, he worked hard on the execution of this object, and rendered it well, but not as easily as he had at first imagined.'

It is worth pointing out that Chardin learned this

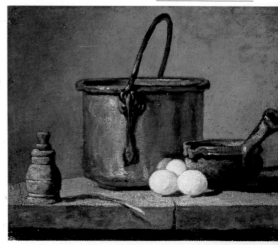

lesson from a history painter, even though he later concentrated on still life, which undoubtedly required less invention than historical scenes, and was accepted into the Académie as a painter 'with a talent for animals and fruit'. He did try to distance himself a little from the genre with which his name became so closely associated, the lowest category of all, and in 1733 broadened his repertoire to include genre scenes, and even tried his hand at portraiture in 1746 and 1757. However, this venture drew a muted response from the critics and Chardin never repeated the attempt, except in the remarkable pastel portraits executed at the end of his life.

Chardin remained a painter in the 'minor genre'. Jean-Baptiste Marie Pierre, First Painter to the King, had no scruples about reminding the ageing painter of the fact

From 1730 Chardin revealed his unusual taste for a painter of his period in painting everyday objects and kitchen scenes, but without ever lapsing into vulgarity or familiarity. In the genre scenes as in the still lifes – *Tinplated Copper Cauldron...* (below opposite) and *Pestle and Mortar...* (below) – the same utensils recur: a copper cauldron, a bowl, a pestle....

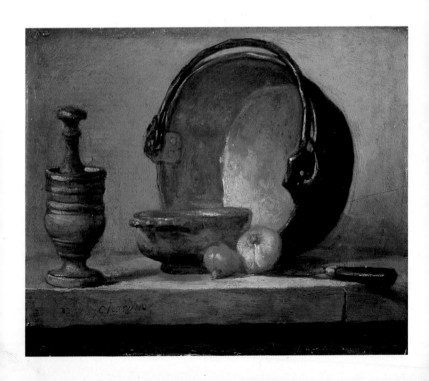

in a letter of 1778: 'You must acknowledge that, for the equal amount of work, your studies have never involved such great expense or such considerable loss of time as they did for your colleagues who pursued the major genres.' The critics also had difficulty in concealing their lack of regard for the 'minor genre' and even Diderot sometimes tempered his praise of Chardin's qualities by recalling the genre in which they were expressed. Thus in 1761, 'Chardin shows originality in his genre,' and very directly in 1765, 'Chardin's genre of painting is the easiest'.

This assessment of the quality of works of art by their subject matter obviously influenced their market value, and while the price of a Chardin canvas rose considerably during his career, it remained far below the amounts achieved by his contemporaries in the major genre. In 1752, when *The Bird Organ* was sold to the king for 1500 livres, only Sébastien Leclerc received less. Paintings by Jacques-Augustin Sylvestre, Carle Van Loo, Jean Bernard Restout, Jean-Baptiste Oudry or Charles-Antoine Coypel ranged between 1600 and 8000 livres. Jean-Marc Nattier earned 15,900 livres for each of his portraits of the royal family.

'A brush with the wings of time' (Diderot)

Although Chardin suffered from the lack of esteem given to his pictures, he continued to serve the Académie that promoted the dogma justifying this discrimination. Chardin had no spark of rebellion in him. All his battles were fought within the Académie, when he attempted to branch out as a painter of genre scenes and portraits, only to return in 1748 to still life, the genre at which he excelled and in which his genius and modernity found their finest expression. Diderot had foreseen this in 1767: 'I am well aware that Chardin's models, the inanimate nature he copies, do not change in place,

The bird organ (opposite) is a small organ used to teach canaries to sing. This picture, which was shown at the Salon of 1751, confirms the changes in the painter's brushwork that occurred in mid-century. With the interiors now unashamedly bourgeois, and the women no longer servants or mothers, the brushwork alters in order to reflect the new subject matter, with the characteristic grainy touch giving way to a more refined and porcelain-like finish. For the first time, pastel shades make an appearance.

Memoire d'un Tableau Representant une Dame assise dans un fauteuil se jouant de la Serinette auprès d'un Serin qui a fait pr.l le service du Roi pendant l'année 1751.

Estimé 1500.lt

in colour or in shape and that, both being of equal perfection, a portrait by La Tour has more merit than a genre piece by Chardin. But a brush with the wings of time will not leave anything to justify the former's reputation. The precious dust will come off his canvas, half scattered on the winds, half sticking to old Saturn's long feathers. We will still talk of La Tour, but we will see Chardin.'

T*he Bird Organ* (below) was the first royal commission Chardin ever received, eleven years after he had given *Saying Grace* and *The Diligent Mother* to Louis XV. A pendant commissioned in 1752 was never executed.

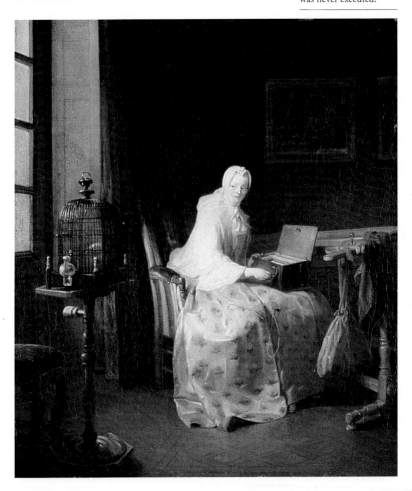

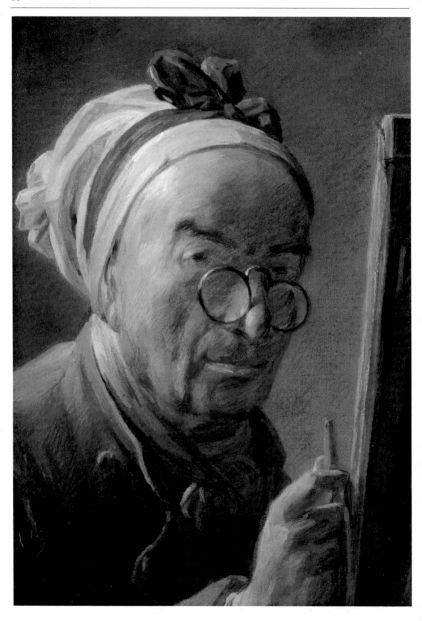

Although Chardin was ambitious to succeed, he never attempted the genres most sought after by collectors and the nobility. Precisely because he stood apart from the mainstream and resolutely pursued his own path, he is recognized today as a precursor of modern painting.

CHAPTER 3

CHARDIN AT WORK

It was only in his very last *Self-portrait* (c. 1779; opposite) that Chardin showed himself in his studio, before his easel, confronting the spectator. In 1867 Philippe Rousseau chose another of the self-portraits as the focus of his still life (right) showing the objects Chardin most liked to paint.

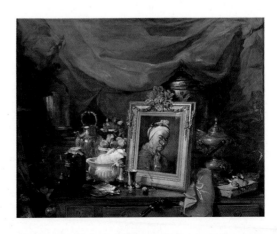

Although history painting was the most highly regarded genre, Chardin never once tried his hand at it. When he attempted to broaden his appeal by extending his range in 1733, it was to genre scenes that he turned, a very minor concession to public taste.

Neither romantic…

The genre scene in 18th-century France was principally concerned with the evocation of the world of elegance

Despite the caption that accompanies the engraving, *Lady Sealing a Letter* (1733; below) is more domestic than romantic. The faces are calm and the action, which may relate indirectly to a romantic situation, is deferred to another time and place.

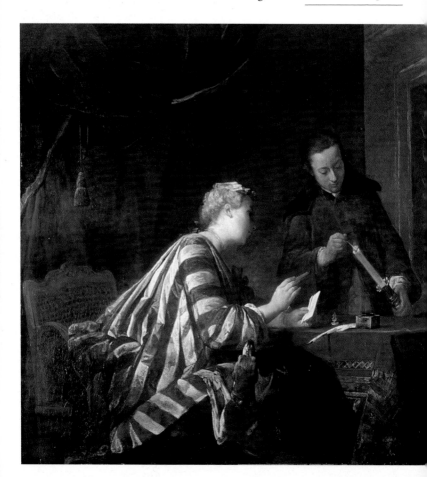

inhabited by the nobility, at play and in their idle moments. Whether the aristocratic assemblies of Jean-Baptiste Van Loo, with whom Chardin worked, or Boucher's beribboned beauties in their gardens, the paintings were essentially light-hearted, more to do with enjoyment than truth. The genre reached its peak in pictures of court entertainments, open-air fêtes and the romantic interludes in which Jean-Honoré Fragonard excelled.

There is nothing of that in Chardin, with perhaps the sole exception of *Lady Sealing a Letter*, one of his first genre scenes. Although it includes all the elements of an amorous encounter – two young people in a darkened room closed off by heavy crimson hangings – the young man is not the lover, but the servant about to light the candle with which to seal the letter addressed, presumably, to the lover. Chardin was not interested in intense emotions and the amorous adventure was not a subject he relished. In fact, this painting is the only one in Chardin's work that in any respect resembles a romantic interlude.

G reuze's *The Village Bride* (above) and Boucher's *La Belle Cuisinière* (below) are good examples of the genre scenes most prized in Chardin's day. Domestic or romantic in theme, they were above all lively, dominated by action and the expression of feeling.

... nor edifying

Nor did Chardin show any interest in the domestic or sentimental subjects that constituted another strand of genre painting in 18th-century French art. The dominant figure in this field was Jean-Baptiste Greuze (1725–1805), with works such as *The Paralytic*, *The Village Bride* and *The Dead Bird*. These scenes were staged in modest settings, and in that respect at least resemble Chardin. However, where Greuze's characters are actors in a scene with a moral, thereby appealing to the spectator's conscience,

Chardin's figures offer no such uplifting example. There is no liveliness in them, no suggestion of a story or anecdote attached to their presence; their gestures remain entirely calm and unemphatic, so that the atmosphere of these pictures is scarcely any different from that of the still lifes.

Chardin rarely includes more than three figures, always women, children or adolescents. They betray no hint of strong emotion. Sometimes looks are exchanged, but it is the watchful gaze of the mother encountering the attentive, obedient eyes of her child. There is no confrontation in the exchange, no visible tension. The mother is less aware of herself than of her child, over whom she watches benevolently.

It is the same with the solitary figures: *The Young Draughtsman* and *The Scullery Maid* have the same expressions; they are entirely absorbed in their tasks. Chardin does not even make these peaceful faces the focus of his scenes; the figures are shown, standing or sitting, on a level with, and a little removed from, the spectator.

Facing his models

The rare oil portraits undertaken by Chardin exhibit the same reticence as the genre

The Scullery Maid (1738; below) and *The Young Draughtsman* (1737; opposite) both date from the same period, about ten years after Chardin's reception at the Académie. He soon abandoned his isolated figures of servants and children to concentrate on domestic scenes.

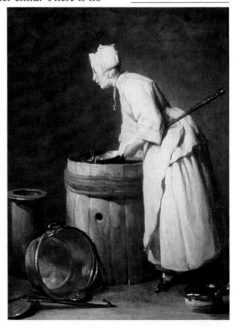

scenes in dealing with the human figure. *Le Souffleur* represents Chardin's friend the painter Joseph Aved seated at a table, absorbed in reading a large volume. To one side are placed a number of objects, an inkwell, an hourglass and some books. However, although the

This detail from *The Good Education* (1749; opposite above) focuses on the faces' expressions, typical of Chardin's figures.

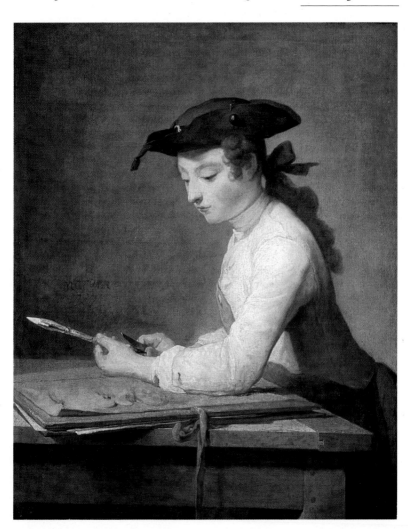

model is painted life size, the artist seems to feel he does not fill the picture space adequately, even with the various objects, for he has added – somewhat artificially – a lighter background consisting of a few bottles on a ledge, as in a still life.

Of all Chardin's portraits in oils, the *Young Man with a Violin* is the only figure who looks straight at the spectator. The sitter is Charles Theódose Godefroy, son of the jeweller Charles Godefroy, Chardin's friend and probably the person who commissioned the painting. Even with the help of the violin, the musician cannot manage to look natural. The hint of a smile at the corner of the mouth indicates the pose and this, together with the strange fixed look in his eyes, is the mark of the embarrassment that comes from knowing you are being watched.

There are other faces painted in close-up in Chardin's work, but they cannot be included in the category of portraits. *Lady Taking Tea* (1735), *House of Cards* (c. 1737), showing the son of Monsieur Le Noir amusing himself by building a house of cards, *Child with a Spinning Top* (c. 1737), are all viewed in profile and head and shoulders only. None of them looks directly at the spectator. The *Young Student Drawing* (c. 1733–4), seated on the floor, has his back turned. It is also known as *The Draughtsman*.

An enclosed space

Chardin had difficulties with the human figure. He would set it back in space, surround it with objects, focus attention away from it. It is, after all, remarkable that, as an

The model for *Young Man with a Violin* (opposite) is the elder brother of the *Child with a Spinning Top*. The insecure stance of the young man and his air of embarrassment help to date the canvas to 1734–5. The way the model turns to look straight at the spectator is an innovation Chardin did not repeat, except in the lost work *Portrait of Mademoiselle Mahon*, which is known from an engraving.

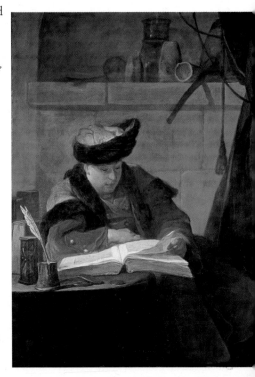

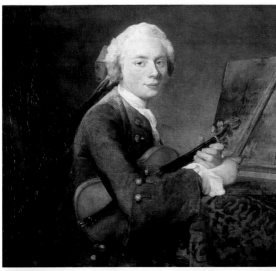

Portrait of the Painter Joseph Aved (opposite) was known by three different titles in the 18th century. At the Salon of 1737 it was originally called *The Chemist*, though it was later engraved under the title *Le Souffleur*. It was finally entitled *The Philosopher* at the Salon of 1753. A contemporary critic identified the model with Joseph Aved. Baron Melchior von Grimm confided to Diderot in 1753, 'This painting seemed very beautiful to me and worthy of Rembrandt,

18th-century painter, Chardin left no oil portraits of women. However, if he did not try to bring out individual features, if he painted figures occupying a totally separate space from that of the spectator, it was in order to capture them in a better way in their own environment.

Chardin's pictorial space has characteristics that recur from painting to painting. Above all, it is enclosed. It is extremely rare to find a Chardin of an exterior. *The Hound* (c. 1724–5) is an exception, but it was one of his earliest works and the hazy lighting is nothing like the full glare of daylight.

All the other Chardin canvases that include figures are scenes of interiors. Even where they feature a window, as in *The Bird Organ* and *The Good Education*, it is seen at an angle and there is no view beyond it to a landscape

although it has hardly been mentioned,' and in the same year the critic Pierre Estève wrote, 'You could take it for a Rembrandt.' The comparison with Rembrandt was probably made because of the colours, notably the harmonies of red and yellow, and the shadow cast over the model.

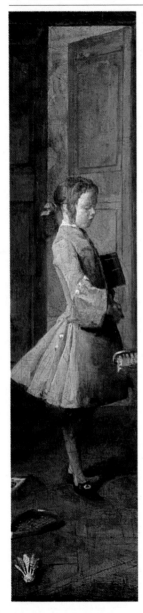

or street. Nor does the half-open door that sometimes appears in these bourgeois interiors reveal the wider world beyond. In *The Diligent Mother* it is masked by a screen and in *The Governess* offers no view of the adjoining room. Only very rarely does it reveal another scene, as in *Girl Returning from the Market*, where, in the background and in brighter light, a cistern is visible, and behind that a young woman in profile, facing another doorway and speaking to someone almost hidden from view. Although it is easy to make out the copper of the cistern, the young woman herself appears ghostly and insubstantial, evidence of Chardin's difficulties in painting on several different spatial planes.

Circulating air

There is movement of two sorts in Chardin's genre scenes. On the one hand the figures are pushed back a little from the picture plane, on the other hand the space behind the figures is closed off, concentrating the attention on to the painted scene. Air circulates in this space left around the figures. The presence of such zones of air and empty space has

The Good Education (opposite below), begun in 1748, was exhibited at the Salon of 1753. It was one of the last genre scenes before Chardin returned to still life, and it shows a clear alteration in technique. The brushwork is now almost invisible, and more unified, giving the picture a slightly misty appearance that was denounced by the critics. The colours are altogether softer, foreshadowing the harmonies of the late pastels.

The Governess (overleaf right and detail left) and *Saying Grace* (overleaf left) were shown respectively at the Salons of 1739 and 1740. Chardin's first genre scenes with more than one character, they were favourably received by critics and public alike. Opposite right: *Girl Returning from the Market* (detail, 1739).

°If we were to report here all the praise given to this delightful painter, this article would take up more room than any of the rest. The schoolboy told off by his governess for getting his hat dirty [detail, left] is the piece that won most approval.°

Mercure de France,
September 1739

the effect of unifying the figures and the other elements of the scene. Yet this integration is never forced. On the contrary, the painter chooses familiar settings that will allow him to integrate the characters with their environment in a natural way. In the case of the adult male figures this integration is sometimes a little laboured, as in the *Portrait of the Painter Joseph Aved*, where a number of objects have been added to balance the composition.

With women and children it is much easier because of their traditional role in the household, enabling them to appear perfectly natural without the need to adopt a pose. The women are entirely familiar with their kitchen utensils and household objects, just as the children are with their toys. These things are more than attributes, they are true companions, silent witnesses of a domestic world of which they also form an integral part.

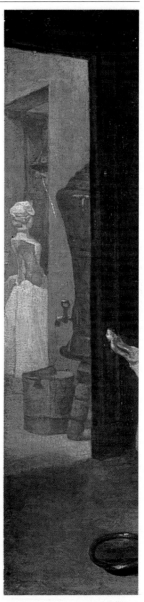

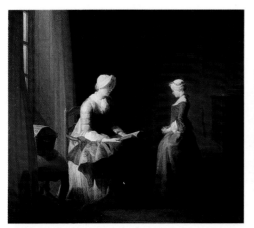

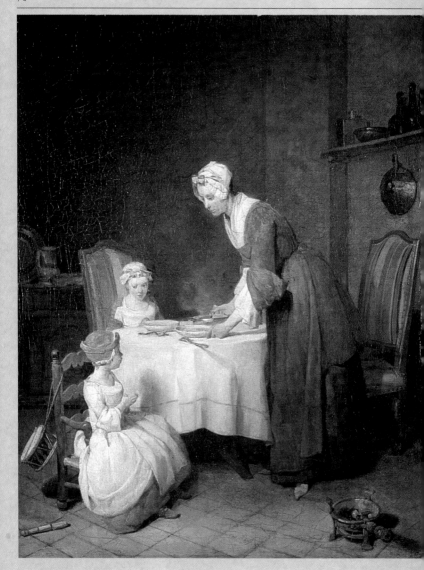

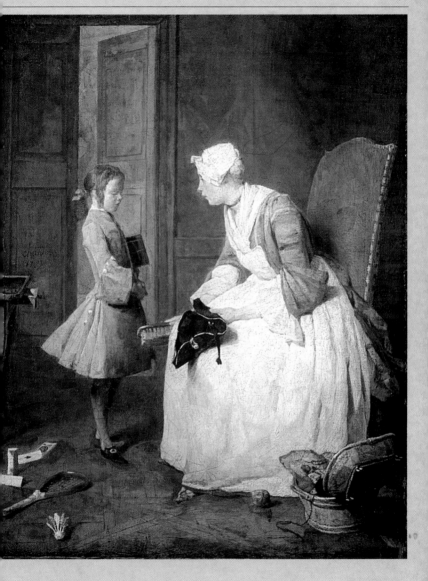

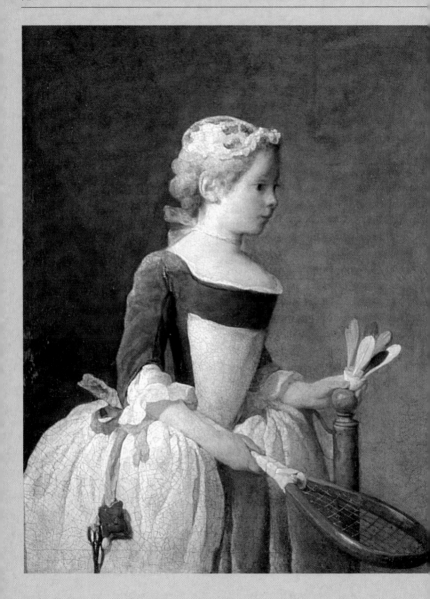

A pendant to *The Good Education*, *The Drawing Lesson* (1748; left) was the first work in which Chardin used Pigalle's cast of *Mercury*, later seen in *The Attributes of the Arts and Their Rewards* of 1766. It was the only picture Chardin exhibited at the 1748 Salon, a failure attacked by the critics. Chardin had already returned to still life and in that year painted *Dead Partridge, Pear and Noose on a Stone Table* (opposite above), although he never showed it at the Salon.

...nes. The external ...es is not his world. ...a strictly limited ...n bodies or objects ...er, the animate forms ...more than the ...n. What Chardin ...of things, infinite ...nt, and the mystery ...ts.

...enre scene *The* ...ainted the still life ...*Stone Table*. Over ...radually became ...became more and ...d at the Salons of ...ks or replicas. ...still lifes.

...the following ...le days and ...ront of immobile,

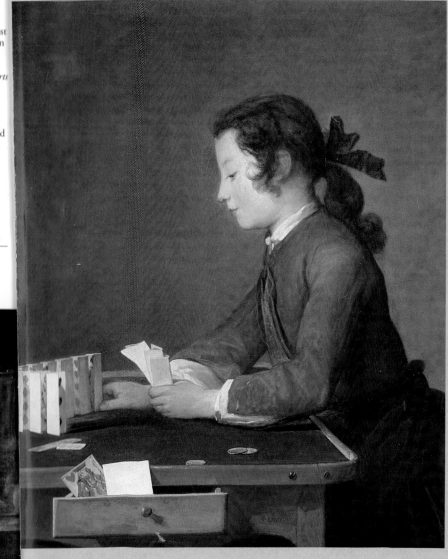

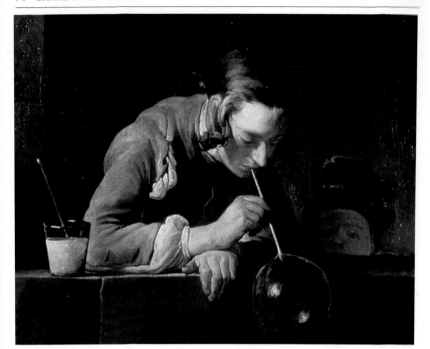

Subtle harmony

This relationship between people and objects is never expressed in terms of an action by the one on the other. Chardin's figures do not move, and the impression of immobility is reinforced by their proximity to some solid object, such as a table, a chair or a desk (even with the piece of furniture to his left, the position of the *Young Man with a Violin* is still unclear and it is hard

Chardin painted the subject of *Soap Bubbles* (c. 1734; above) several times. A common theme in Dutch 17th-century painting and adopted during the 18th century in France, it is generally treated as a 'vanity', symbolizing the frailty of human life. Yet nothing in Chardin's picture, exhibited in 1739, warrants that interpretation. It features one of the first faces Chardin painted in close-up, the detail emphasized by the dark stone background.

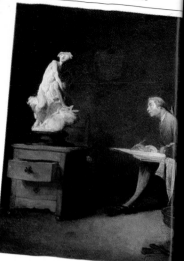

to tell if he
figures in
lifes on fla
are combi
his elbow
is set a gl

A dom
distancin
moveme
scene by
as a grea
characte
observe
have ar
attenti
with e

'On
Chard
'feelin
which
Prous
affini
hand
table
and
of a
– be
whe
feet
ten
the
– h
an

Chardin is not a painter of ther
world of actions, history and stori
What he paints are forms, and in
setting. Whether they are of huma
is of little significance to the paint
do not 'externalize' themselves any
inanimate: their true life lies withi
seeks, and captures, is the mystery
in their disposition and utterly sile
of our continually repeated daily a

In 1748 Chardin sent only the g
Drawing Lesson to the Salon, but p
Dead Partridge, Pear and Noose on
the next twenty years the still lifes
more frequent and the genre scenes
more rare, until the last few exhibit
1757 and 1773 were either old wor
Chardin was once again a painter o

'You have to train the eye...'

In his *Salon* of 1765 Diderot quoted
words by Chardin: 'After interminab
nights burning the midnight oil in f

inanimate nature, we are presented
with living nature; and suddenly
the work of all the preceding years
seems reduced to nothing: one was
no more awkward the very first time
one picked up a pencil. You have to
train the eye to look at nature; and
how many have never seen it and
never will.' Looking at nature was
Chardin's constant preoccupation,
although for him it was confined
to a few objects subjected to intense
scrutiny. The things he painted at

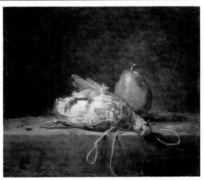

the very start of his career were the things he returned
to in 1748. Inanimate nature did not distract the eye
or present the same problems as the human body.

Whether it is a case of the early or the late still lifes,
the painter's preference is always for everyday objects,
probably things he had in his home, judging by the
various inventories drawn up at regular intervals during
his life. Many of Chardin's canvases, for example,
contain the same silver goblet, the same water jug, the

In the still lifes painted
after 1748, such as
*Seville Orange, Silver
Tumbler...* (below
right), the same objects
appear as in paintings
from the late 1720s like
Still Life with Carafe...
(below left). Yet the
composition is more
rigorous and simplified.

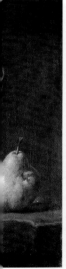
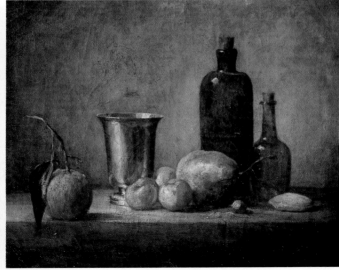

This copy of a sculpted bas-relief (left), entitled *Bacchante Milking a Goat Held by a Child*, is one of the few examples of the use of trompe-l'oeil by Chardin. He had experimented with the technique early in his career and returned to it in 1769 with two grisaille copies of bas-reliefs by Gérard Van Opstal, this being one of them. It is not certain what made him go back to trompe-l'oeil, but it may have been in response to commissions.

same cauldron and the same cistern. As for the dead animals, with the exception of *The Skate*, they are nothing more exotic than hares, ducks or partridges.

Trompe-l'oeil?

In only a very few canvases do more unusual items appear, such as the decorative works commissioned by the Comte de Rothenbourg in 1730, which feature a parrot, the overdoors for the Châteaux of Choisy and Bellevue dating from 1764 and 1766, the *Monkey as Painter* and *Monkey as Antiquarian* (both c. 1738–40), and also his grisaille bas-reliefs, some of which portray scenes from antiquity. The choice of more unusual objects was made purely to satisfy the requirements of the decorative genre, and represents one of Chardin's rare concessions to popular

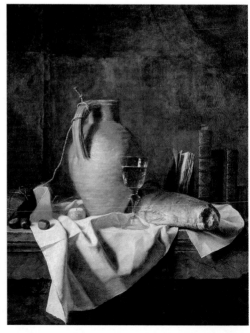

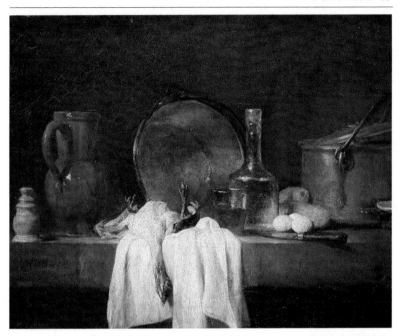

taste. The most striking examples are undoubtedly the monochrome bas-reliefs that imitate the effect of sculpture. They illustrate the 18th-century taste for illusionism, verging sometimes on trompe-l'oeil.

Chardin used trompe-l'oeil only in his bas-reliefs, unlike artists such as Roland Delaporte and, above all, Jean-Baptiste Oudry, who employed the technique extensively in still lifes. Oudry in particular, with his precision of line and touch and careful graduation of the colours, reduced to a few basic harmonies, was capable of rendering the smallest relief, making the object stand out against its pale background and actually appear palpable. Chardin never really ventured into trompe-l'oeil proper. The technique demands a precise and defined drawing style that was foreign to him. (Chardin hardly ever made preparatory drawings, but expressed form directly through the application of colour with his brush.)

A comparison of Chardin's *The Kitchen Table* (above) with Roland Delaporte's *Preparations for a Country Lunch* (opposite below) demonstrates Chardin's originality. Both works show objects on a kitchen table, including a crumpled tablecloth. In the Delaporte the objects seem marooned and unconnected, while in the Chardin there is a unity of composition, with colours and volumes in harmony.

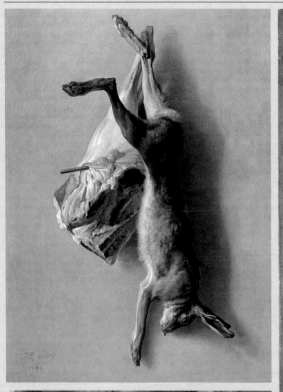

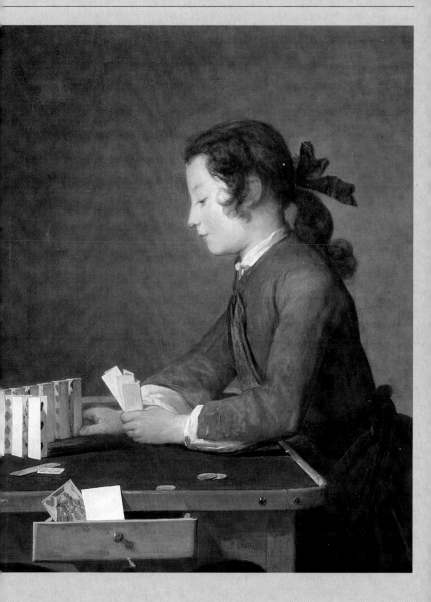

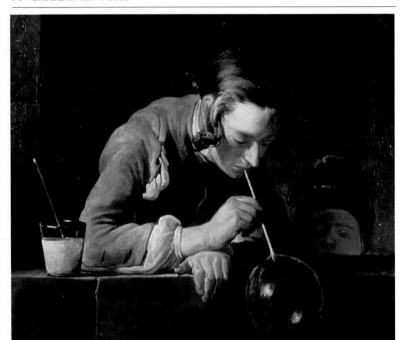

Subtle harmony

This relationship between people and objects is never expressed in terms of an action by the one on the other. Chardin's figures do not move, and the impression of immobility is reinforced by their proximity to some solid object, such as a table, a chair or a desk (even with the piece of furniture to his left, the position of the *Young Man with a Violin* is still unclear and it is hard

Chardin painted the subject of *Soap Bubbles* (c. 1734; above) several times. A common theme in Dutch 17th-century painting and adopted during the 18th century in France, it is generally treated as a 'vanity', symbolizing the frailty of human life. Yet nothing in Chardin's picture, exhibited in 1739, warrants that interpretation. It features one of the first faces Chardin painted in close-up, the detail emphasized by the dark stone background.

to tell if he is standing or sitting). Chardin 'places' his figures in space, in the same way as he sets out his still lifes on flat surfaces. In *Soap Bubbles*, the two processes are combined: a young man blows soap bubbles, resting his elbows on a flat surface – a window sill – on which is set a glass of soapy water.

A domestic world, nothing exceptional, a certain distancing of the figures, a deliberate absence of movement, those are the main characteristics of a genre scene by Chardin. The painter does not set himself up as a great organizer of compositions with numerous characters, any more than as a critical or compassionate observer of his society. The reality he portrays does not have any particular message or meaning. He looks attentively, and that alone is enough to fill him with emotion.

'One uses colours, but one paints with feeling,' Chardin declared, in Cochin's account. Chardin's 'feeling' is above all the warmth and tenderness with which he observes his subjects, something noted by Proust in 1895 with reference to *Saying Grace*: 'The affinity…between the inclined body, the contented hands of the woman setting the table and the ancient tablecloth and the plates still intact after so many years and whose smooth firmness she has felt the resistance of always in the same spot between her careful hands – between the light and all this room that she caresses, where she falls asleep, where sometimes she drags her feet, sometimes comes in gaily, as it takes her, with such tenderness after so many years – between the heat and the fabrics – between the people and the things – between the past and present life – between light and dark.'

Girl with a Shuttlecock and *The House of Cards* (pages 72 and 73) were probably conceived as pendants; they enjoyed a similar fate, and the two subjects were again associated in the replicas in the Uffizi Museum in Florence. Both were probably exhibited at the Salon of 1737 and later acquired by Catherine the Great in the 1770s. Like *Child with a Spinning Top* (detail, below), they evoke the world of childhood. The girl, although preparing to launch her shuttlecock, is absolutely still. Even her face resembles a doll's. The boy, still wearing an apron, has probably broken off from his studies to build his house of cards.

In *Saying Grace* (detail, opposite below), the only visible movement comes from the steaming soup.

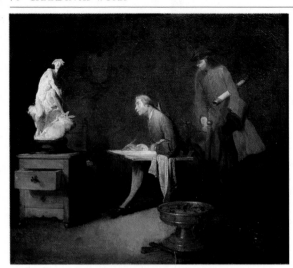

A pendant to *The Good Education*, *The Drawing Lesson* (1748; left) was the first work in which Chardin used Pigalle's cast of *Mercury*, later seen in *The Attributes of the Arts and Their Rewards* of 1766. It was the only picture Chardin exhibited at the 1748 Salon, a failure attacked by the critics. Chardin had already returned to still life and in that year painted *Dead Partridge, Pear and Noose on a Stone Table* (opposite above), although he never showed it at the Salon.

Chardin is not a painter of themes. The external world of actions, history and stories is not his world. What he paints are forms, and in a strictly limited setting. Whether they are of human bodies or objects is of little significance to the painter, the animate forms do not 'externalize' themselves any more than the inanimate: their true life lies within. What Chardin seeks, and captures, is the mystery of things, infinite in their disposition and utterly silent, and the mystery of our continually repeated daily acts.

In 1748 Chardin sent only the genre scene *The Drawing Lesson* to the Salon, but painted the still life *Dead Partridge, Pear and Noose on a Stone Table*. Over the next twenty years the still lifes gradually became more frequent and the genre scenes became more and more rare, until the last few exhibited at the Salons of 1757 and 1773 were either old works or replicas. Chardin was once again a painter of still lifes.

'You have to train the eye...'

In his *Salon* of 1765 Diderot quoted the following words by Chardin: 'After interminable days and nights burning the midnight oil in front of immobile,

inanimate nature, we are presented
with living nature; and suddenly
the work of all the preceding years
seems reduced to nothing: one was
no more awkward the very first time
one picked up a pencil. You have to
train the eye to look at nature; and
how many have never seen it and
never will.' Looking at nature was
Chardin's constant preoccupation,
although for him it was confined
to a few objects subjected to intense
scrutiny. The things he painted at

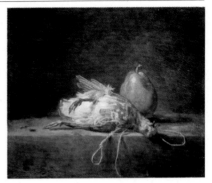

the very start of his career were the things he returned
to in 1748. Inanimate nature did not distract the eye
or present the same problems as the human body.

Whether it is a case of the early or the late still lifes,
the painter's preference is always for everyday objects,
probably things he had in his home, judging by the
various inventories drawn up at regular intervals during
his life. Many of Chardin's canvases, for example,
contain the same silver goblet, the same water jug, the

In the still lifes painted
after 1748, such as
*Seville Orange, Silver
Tumbler...* (below
right), the same objects
appear as in paintings
from the late 1720s like
Still Life with Carafe...
(below left). Yet the
composition is more
rigorous and simplified.

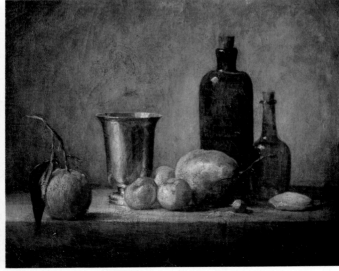

This copy of a sculpted bas-relief (left), entitled *Bacchante Milking a Goat Held by a Child*, is one of the few examples of the use of trompe-l'oeil by Chardin. He had experimented with the technique early in his career and returned to it in 1769 with two grisaille copies of bas-reliefs by Gérard Van Opstal, this being one of them. It is not certain what made him go back to trompe-l'oeil, but it may have been in response to commissions.

same cauldron and the same cistern. As for the dead animals, with the exception of *The Skate*, they are nothing more exotic than hares, ducks or partridges.

Trompe-l'oeil?

In only a very few canvases do more unusual items appear, such as the decorative works commissioned by the Comte de Rothenbourg in 1730, which feature a parrot, the overdoors for the Châteaux of Choisy and Bellevue dating from 1764 and 1766, the *Monkey as Painter* and *Monkey as Antiquarian* (both c. 1738–40), and also his grisaille bas-reliefs, some of which portray scenes from antiquity. The choice of more unusual objects was made purely to satisfy the requirements of the decorative genre, and represents one of Chardin's rare concessions to popular

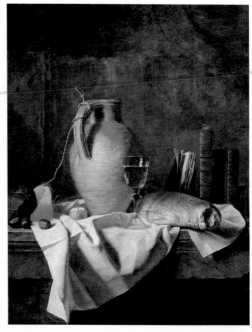

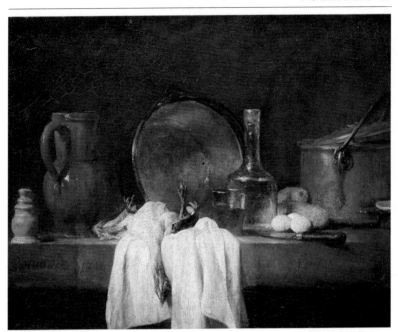

taste. The most striking examples are undoubtedly the monochrome bas-reliefs that imitate the effect of sculpture. They illustrate the 18th-century taste for illusionism, verging sometimes on trompe-l'oeil.

Chardin used trompe-l'oeil only in his bas-reliefs, unlike artists such as Roland Delaporte and, above all, Jean-Baptiste Oudry, who employed the technique extensively in still lifes. Oudry in particular, with his precision of line and touch and careful graduation of the colours, reduced to a few basic harmonies, was capable of rendering the smallest relief, making the object stand out against its pale background and actually appear palpable. Chardin never really ventured into trompe-l'oeil proper. The technique demands a precise and defined drawing style that was foreign to him. (Chardin hardly ever made preparatory drawings, but expressed form directly through the application of colour with his brush.)

A comparison of Chardin's *The Kitchen Table* (above) with Roland Delaporte's *Preparations for a Country Lunch* (opposite below) demonstrates Chardin's originality. Both works show objects on a kitchen table, including a crumpled tablecloth. In the Delaporte the objects seem marooned and unconnected, while in the Chardin there is a unity of composition, with colours and volumes in harmony.

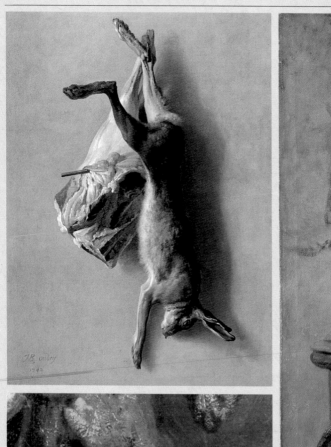

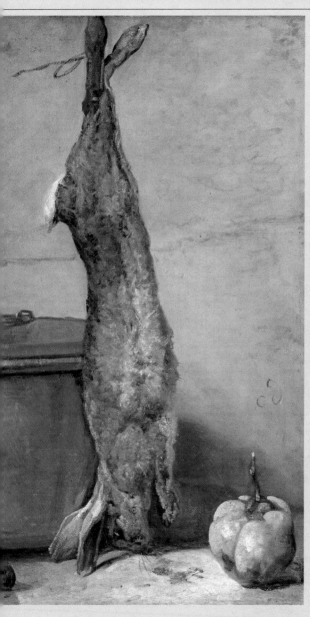

A comparison of these two studies of dead rabbits – Oudry (opposite above left) and Chardin (left and detail opposite below left) – reveals the differences between the two still-life painters. First, Oudry's background is perfectly uniform and abstract, while Chardin's consists of a realistic wall, its rough texture accurately rendered; Chardin also adds a horizontal plane, defining the space. Oudry's rabbit hangs close to the wall and stands out sharply against it, casting a shadow. The illusion sought here relies purely on the contrasts between materials and the relief artificially created by the lighting, with light and shade sharply differentiated. In the Chardin canvas there are no chiaroscuro effects or contrasting treatments of different materials. The stone wall looks like the stone wall that it is, the rabbit has a rabbit's fur, viewed at least from a distance. Together with the cauldron, quince and two chestnuts, they are subsumed within a single, unified vision.

'From the bottom to the top', or the magic of colour

Chardin's use of colour was no less skilled than Oudry's, but bore no resemblance to the smooth almost photographic finish achieved by the latter. On the contrary. 'This magic is beyond comprehension. Thick layers of colour are applied one on top of the other, the effect seeping through from the bottom to the top. At times it is as if a mist has been blown on to the canvas; and sometimes as if a light foam had been thrown over it…. Come close and everything becomes blurred, goes flat and disappears; stand back and everything comes together and takes shape again,'

exclaims Diderot in his *Salon* of 1763.

In 1979 the laboratories of the Louvre undertook an analysis of the pigments used in *Jar of Olives*. It confirmed everything Diderot said, revealing the existence of two distinct levels of paintwork. The first level consists of a layer of orange red covered with a thicker layer of pale greyish beige. The second level comprises several layers of colour applied one on top of the other. Chardin obtained his final shades through effects of transparency, achieved by superimposing comple-mentaries. He never used pure colour. Highlights and volumes were rendered by the technique of scumbling, lifting off the upper layers with the brush to reveal, to a greater or lesser degree, the layers underneath. The

Dated 1760 and exhibited at the Salon of 1763, *Jar of Olives* (above, with details left and opposite) won high praise. Diderot reports that when Greuze saw it as he went upstairs to the Salon, he let out a sigh: 'His praise is more succinct and more eloquent than mine.' And later: 'If I wanted my child to be a painter, this is the picture I would buy. "Make me a copy of this," I would tell him, "and then copy it again".'

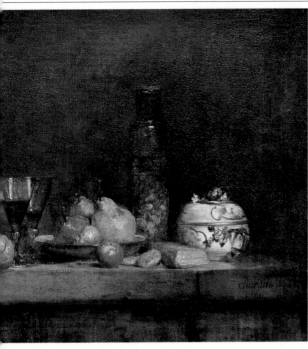

For this porcelain bowl is made of real porcelain; these olives really do look as if they are floating in water; these biscuits are just waiting to be picked up and eaten, this Seville orange to be split open and squeezed, this glass of wine to be drunk, this fruit to be peeled, this pie to be cut into.
Diderot,
Salon of 1763

brushmarks usually remained visible, giving Chardin's canvases their characteristically grainy look. Only his very last oils have a smoother finish, although never that porcelain perfection popular in his day.

From simplification...

Chardin's oil paintings are characterized not only by their distinctive handling but also by the extreme compactness of their composition, which is devoid of superfluous ornament. The dead animals and kitchen utensils alike are placed almost invariably on a rough stone surface. The background is also left bare, and the stone wall visible in an early painting such as *The Skate* becomes increasingly abstract, as in *Basket of Peaches, Black and White Grapes, with Cooler and Stemmed Glass.*

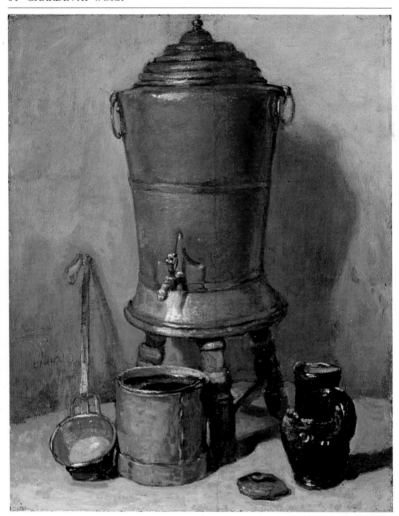

Another feature of the still lifes, apart from a very few canvases, such as *The Buffet* and *The Pantry Table*, is that they contain relatively few objects. *The Copper Cistern* is a typically stark example, 'its weight and substance and fidelity to the object worthy of a meditation by Descartes', wrote André Gide. The

A grey wall, a copper cistern and a few utensils, that is all, and yet *The Copper Cistern* (c. 1734; above) is one of Chardin's most perfect compositions.

pictures of game are similarly bare. There is the same compact composition, with usually no more than one dead creature lying beside a gamebag.

... to simplicity itself

After 1759 the composition became even simpler and the effect of luminosity more marked. The objects moved nearer to the picture plane, and included more valuable items. *Jar of Olives, Grapes and Pomegranates* and *The Brioche* feature, respectively, a Meissen porcelain bowl, a water jug with coloured motifs and silver-gilt mount, and a carafe with a gilt stopper. At the Salon of 1763 they won Chardin enthusiastic praise. In *L'Année littéraire* Elie Fréron declared the pictures 'were the finest by him we have yet seen'. Diderot said of *Jar of Olives*: 'When looking at paintings by other artists, I feel that I need new eyes; when looking at paintings by Chardin, I need only use those which nature gave me and use them well.' And two years later: 'Here you are again, you great magician with your silent compositions!'

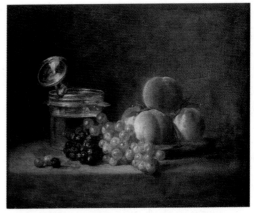

Basket of Peaches, Black and White Grapes, with Cooler and Stemmed Glass (above) was shown at the Salon of 1759, *The Brioche*

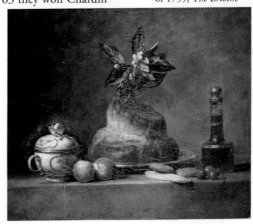

(above) at that of 1763. Chardin was then at the peak of his powers. His rigorous sense of composition did not stop him adding touches like the orange blossom.

How to look at a painting...

The exact circumstances of Chardin's meeting with Diderot or the precise nature of their relationship are unknown. Chardin no doubt taught Diderot a lot about

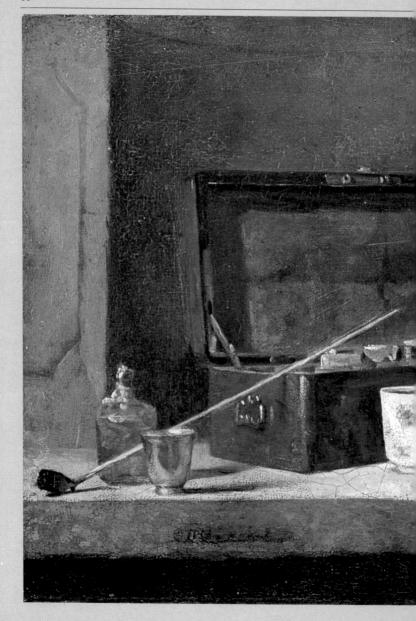

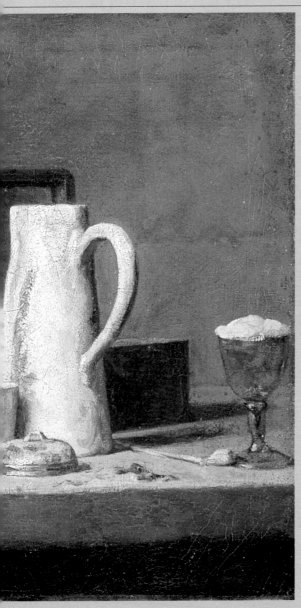

The Smoker's Box, also known as *Pipes and Tumbler* (c. 1737; left) is an unusual work in Chardin's repertoire, unique among the still lifes for the virtual absence of round forms, apart from the discreet curves of the objects in the foreground. Only the handle of the jug disrupts the rigorous composition, which is conceived along contrasting lines, horizontal (the table), vertical (the wall on the left) and diagonal (the box itself and, most strikingly, the long stem of the pipe). However, the effect is not severe, there are no hard edges, such is the softness of the colours with their blue and white harmonies, relieved by small pink flowers on the jug and the pot. Rarely had Chardin achieved such harmony.

Chardin was probably very familiar with this smoking box, as there is a reference in the inventory drawn up after the death of his first wife to a 'rosewood smoking box'. The painting has a very gentle air in spite of its tightly controlled harmony. The 20th-century critic Charles Sterling thought it Chardin's finest still life.

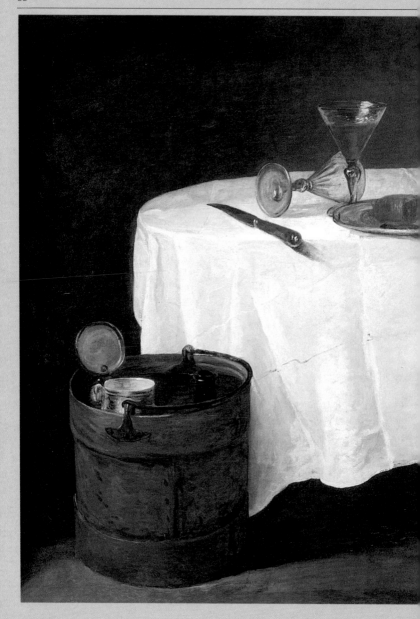

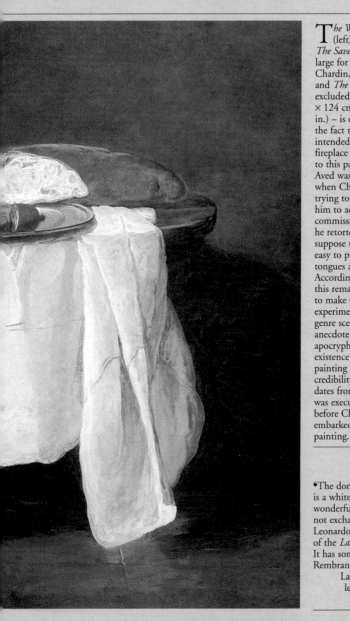

The *White Tablecloth* (left), also known as *The Saveloy*, is unusually large for a still life by Chardin, if *The Skate* and *The Buffet* are excluded. Its size – 96 × 124 cm (37¾ × 48⅞ in.) – is explained by the fact that it was intended for use as a fireplace screen. It was to this painting Joseph Aved was referring when Chardin had been trying to persuade him to accept a portrait commission and he retorted: 'You suppose they are as easy to paint as stuffed tongues and saveloys.' According to Mariette, this remark was enough to make Chardin start experimenting with genre scenes. The anecdote may be apocryphal, but the existence of this painting lends it credibility. The work dates from 1732 and was executed a year before Chardin embarked on genre painting.

⦁The dominant feature is a white tablecloth so wonderful that I would not exchange it for Leonardo's in his fresco of the *Last Supper*.... It has something of Rembrandt about it.⦁

Laurent Laperlier, letter to Thomas Couture, 1878

how to look at a painting, judging by
the philosopher's frequent allusions to
the excellence of the painter's comments
on his art. For his part, Diderot, in his
commentaries on the Salons and later
his essays on painting, continually
speculated about Chardin's work. In
1759 he noted the effect of 'trickery'
on the spectator; in 1763 he
commented that he did not have to
adjust his vision to look at a painting
by Chardin; and, in 1776, speaking
of Vernet and Chardin, he declared
himself defeated: 'Yet they have a clearly
defined technique of their own. I am
sure of it, and I would discover it if I
wanted to take the trouble; but man is not
God; and the artist's studio is not nature.'

The imitation of nature to which Diderot
constantly refers when writing about Chardin has
nothing to do with trompe-l'oeil techniques. Chardin
removes every possible distraction from his gaze and
renounces action of every sort, in order to re-create on
canvas an inner vision of the world, a vision in which
objects are interconnected and stripped of their mystery.

In *Jar of Apricots*
(above) the unusual
oval format emphasizes
the harmony of the
composition, echoing
the shape of the box.

... and of painting truthfully

'How the air circulates around these objects!'
notes Diderot in 1765. In the end it is a very
human vision that Chardin re-creates, not
one that dwells on the thousand and one
peculiarities of things, not analytical, not
descriptive, but one attuned to their remarkable
presence, in their own light and space,
synthetic, poetic.

If Chardin chooses to paint simple objects,
if he encloses space and banishes all action
and decoration, it is in order to bring out the
essence of things, not their outward appearance
but the secret life within them that is revealed
in silence and contemplation. Each object is
invested with the same dignity, the same

grandeur. None takes precedence over the rest, whatever the material differences between a hare and a wall, a glass and a copper cauldron. This subtle harmony is achieved by patient work on colour and light. In the *Basket of Wild Strawberries* the red of the fruit slides round the side of the glass of water in front of the two flowers. It is different from the red of the cherries that lies over the fruit like a coloured film. A delicate and skilful harmony is created from the combination of brown, red and green with the white of the flowers reflected in the glass of water.

Basket of Wild Strawberries (below) was not mentioned by any of the critics. The only way we know it was exhibited at the Salon of 1761 is from the sketch made by Gabriel de Saint-Aubin in his *livret* (catalogue) for the Salon. Yet it is a masterpiece. Given that flowers feature so rarely in Chardin's work, it is also noteworthy for the two carnations (detail, opposite bottom), the stem of one breaking the straight line of the table edge, while the white petals light up the whole composition.

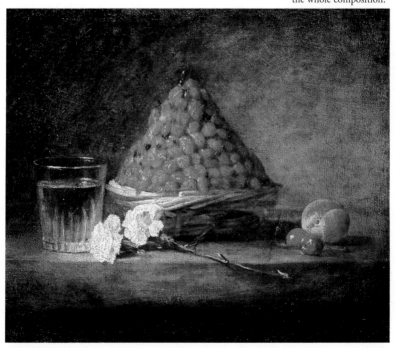

Proper portraits

Just at the time when Chardin had attained a mastery of still life that won him praise from all quarters, he quite suddenly abandoned oil painting. The only new works he submitted to the Salons between 1771 and 1779, the year of his death, were pastels, and, what was even more surprising, they were not still lifes but portraits.

These late works are children's and old men's faces, studies of heads, including one based on a Rembrandt, and, above all, portraits of Chardin himself and his wife. The critics gave them a favourable reception. In 1771 *L'Année littéraire* commented: 'It is a new genre in which we have not previously seen him work, and he has achieved excellent results with his experiments.'

Diderot also expressed his admiration. Just before Neoclassicism began to triumph, Chardin's last stroke of genius commanded the respect of critics already starting to look elsewhere.

In a letter dated 1778 addressed to the Comte d'Angiviller, Marigny's successor, Chardin supplied the explanation for this new departure: 'My infirmities prevented me from continuing to paint in oils, so I have fallen back on pastels.' It is known that Chardin suffered from eye problems and it is likely that mixing binders and pigments had a harmful effect.

However, while it is clear Chardin changed to pastels for reasons of health, this move was more than an alteration of technique, it represented a decisive change in his working habits. For the first time he overcame his reticence towards the human face and painted 'proper' portraits. His figures appear on their own, half length, their faces open to scrutiny.

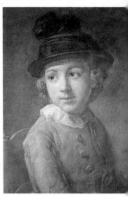

'It is in the portrait of his wife [opposite] that he reveals all his fire, all the power of his eloquence.... Nothing is lacking in this incredible study of an elderly woman, not one line, not one tone. The yellowish ivory pallor of the forehead, the withdrawn expression with no vestige of a smile remaining, the folds around the eyes, the thin, bony nose, the parted lips, the complexion the colour of an overwintered fruit; Chardin records all these signs of ageing; he conveys what old age feels like, the sense almost of its approach, in elusive, inimitable crayon strokes that are somehow capable of quickening the breath on the lips of someone's portrait, imparting the quiver of life to the drawing of a face.'

The Goncourts, 1864

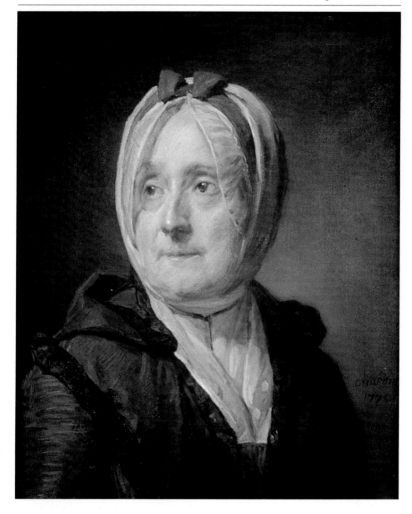

In the last ten years of Chardin's life, during which he produced his portraits in pastel, the fortunes of his friend Cochin suffered a decline. He was replaced at the Académie by Pierre, First Painter to the King, who disliked his predecessor. Chardin found himself without the support he needed and in 1774 resigned as treasurer.

The portraits of children (opposite left and right) were praised at the Salon of 1777, while the more powerful self-portraits passed unnoticed.

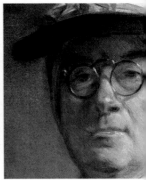

It is worth noting that this partial retreat from society and his illness coincided with greater expression in his art. He began to paint portraits of himself, staring the spectator in the eye. Of course he was posing, with a turban wrapped round his head or with an eye-shade, but these shabby accessories, like the studied casualness of his attire, which, as Proust remarked, gave him the look of an 'English tourist', all focused attention on to the head, held high, the gaze proud and direct, and the mystery of his ageing features.

In the last *Self-portrait* in the Louvre, dating from around 1779, the artist stands before his easel, with his pastel crayon in hand. His face is thinner, his expression less assured but still intense. The suppressed emotion has emerged at last.

Chardin died on 6 December 1779 in his lodgings at the Louvre. He was eighty.

'We will see Chardin'

Chardin's work suffered a period of neglect immediately after his death until the mid-19th century, though it was recognized and honoured by the very greatest artists at the end of that century and the start of the next.

While in the first two Chardin self-portraits (details, above left and centre), an ironic expression plays over the painter's lips, in the third (opposite above) there is no compromise or concealment, and the painter's expression is grave.

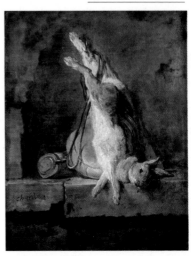

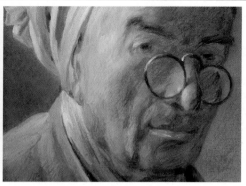

D*ead Rabbit with Gamebag and Powder Flask* (c. 1727–8; opposite below) exemplifies Chardin's obsessive attention to detail in order to achieve the final impression of unity that is so characteristic of his art. It was probably this technique that appealed to Manet, who made a rather free copy of the work in 1866 (below left).

Manet loosely based his study of a dead rabbit on Chardin's *Dead Rabbit with Gamebag and Powder Flask*, Cézanne and Van Gogh, and later Matisse, copied *The Skate* and *The Buffet*. They all admired Chardin and studied him at the Louvre. What they discovered in his work corresponded to their own interests. They were attracted not so much by the subject matter or by any particular technique as by his evident relish of painting itself, in all its glorious variety. That a painting could succeed without the need for a pretext, a story

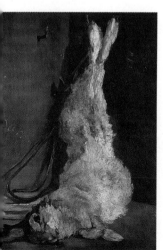

or underlying idea, that it could render with wonderful precision not only the physical reality of things but also the intensity of our emotional relationship with them, that was the truth so subtly revealed by Chardin. It was a revelation that fore-shadowed not only the 'new painting' but the whole of modern art, identifying the painter of *The Copper Cistern* and *Saying Grace* as one of its most influential and most unassuming forerunners.

C*hardin* very rarely painted flower pictures and the example in Edinburgh, *Vase of Flowers* (detail, overleaf), is the only one to have survived. It dates from 1755 to 1760, the period when Chardin's powers were at their height. In 1952 Charles Sterling had this to say about it: 'One could not imagine anything more "advanced" in terms of layout and execution.... Only in Cézanne, only in Vermeer – and one waited in vain for a still life by him – could such serenity have been born of a few harmonies of white and blue in milky daylight.'

DOCUMENTS

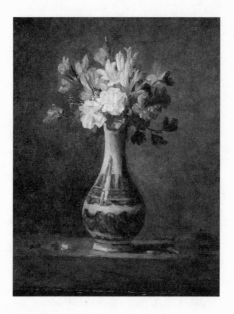

'That is what is so miraculous about the things Chardin
paints: masses and contours modelled, drawn with their own
light, fabricated as it were from the very soul of their colour, they
seem to stand out from the canvas and come alive, through
some indefinable and wonderful optical effect operating
between canvas and spectator.'

Edmond and Jules de Goncourt
L'Art du dix-huitième siècle, 1875

Chardin through the eyes of his contemporaries

The absence of any writings or extensive correspondence by Chardin means that the few first-person accounts of him by his contemporaries are particularly valuable. From them Chardin emerges as a man intolerant of foolishness and self-importance, but full of indulgence towards suffering artists. While Jean-Baptiste Marie Pierre, First Painter to the King, implies he was barely literate – there was a bitter feud between the two men – Chardin's responses show him to be a man of wit and character, and, above all, someone always ready to spring to the defence of his art.

'So puffed up'?

Monsieur Chardin's death had a number of consequences. Our Under Secretary, always pompous, filled three pages of the newspaper and in the end found himself wide of the mark. Between ourselves I will tell you something better not said in public. He was more taken up with those plots and intrigues and whims of his than I would ever have thought, and more than any mere academician had a right to be. The day he was due to receive the last sacraments, one of his nephews sought me out and, after much chit-chat about our excellent curé and some priest friend or other of the dying man, said to me: 'My uncle has not been able to be with you, so it is up to you, etc. Given his condition, you will of course excuse him.' You can judge I made the correct response, as an hour later his pass was being dealt with. That man was so puffed up with the little bit of tawdry fame he got from Cochin's protection that it went to his head and he could not bear being demoted to council member. Scarcely able to read or write his name, he wrote voluminous letters in friends' hands, moving heaven and earth to insist he should not be compromised....

At the last assembly we appointed Monsieur Duplessis to replace him, a man as silent as his predecessor was garrulous, in spite of being deaf.

Jean-Baptiste Marie Pierre
Letter to Joseph Marie Vien,
28 January 1780

A quick wit

Chardin was a small man but strong and muscular. He had spirit and, above all, a great fund of good sense and sound judgment. He had a remarkable ability to express his ideas and convey their

meaning, even in those artistic matters that are difficult to explain, such as the magic of colour and the various ways of producing light effects. He often made lively and unexpected remarks. One day an artist was making a great show of the methods he used to purify and perfect his colours. Chardin grew impatient with this chatter from a man whose works he knew to be executed in a cold and meticulous way, and said: 'But who told you one painted with colours!' 'With what then?' replied the greatly astonished man. 'One uses colours,' replied Monsieur Chardin, 'but one paints with feeling.'

Charles-Nicolas Cochin
'Essai sur la vie de M. Chardin', 1780

Skilful repartee

The painter Chardin, known for his strength and openness of character, could not endure the ignorance of his art shown by high-ranking people. His own high opinion of that art, and the bad temper with which he always greeted impertinent and stupid questions, ensured a sharp rebuke to a lady of quality. 'Monseux, Monseux,' exclaimed the woman, at whose home he was painting. 'Is that really very difficult, what you're doing?' 'You whistle and you waggle your fingers, Madame, that is the trick of it,' the artist replied. 'It's my servant, you see, he's been wielding the brush for a week now; he's already done a three-quarter length portrait. With a few more lessons, he should be able manage a full picture, don't you think?' 'Goodness, Madame, he can manage it right now if you like, since I am leaving.'

Dusaulchoy
Mosaïque historique, politique et littéraire, vol. 2, 1818

A man of conviction

The story is that the pupil of a very accomplished painter copied a painting by his master so perfectly that the latter mistook it for one of his own. I have been told that is impossible by a painter who is alive today and admired for the truth and originality of his works. Chardin claimed that whatever the *copy* of a picture of his was like, he would never mistake it, and that this copy would either be more beautiful (which would be difficult) or less beautiful than the original. People quoted the authorities to him, but he refused to change his mind....

Denis Diderot
Extract from the entry for 'Copy',
Encyclopédie, vol. 4, 1754

Remember what Chardin said to us at the Salon: 'Gentlemen, gentlemen, restrain yourselves. From all the paintings here, find the very worst; and then recall that two thousand wretches bit their brushes in two, despairing they would ever paint that badly. Parrocel, who you call a dauber, and who is one, if you compare him with Vernet; that same Perrocel is nevertheless exceptional in comparison with the many who have abandoned the career they embarked on at his side. Lemoyne said it took thirty years' experience to be able preserve the quality of the original sketch in the finished work, and Lemoyne was no fool. Listen to me, and you might learn some tolerance.'

Denis Diderot, *Salon* of 1765, vol. 2,
ed. Jean Seznec and Jean Adhémar,
1957–67

The Salon of 1763

The Salon was the major artistic event in 18th-century Paris, the occasion when artists measured themselves against their colleagues. The critics added to that rivalry by taking sides with one exhibitor against another. Diderot in particular was no respecter of reputations. In 1763 he even dared to take on the eminent academician Jean-Baptiste Marie Pierre.

EXPLICATION
DES PEINTURES, SCULPTURES,
& autres Ouvrages de Messieurs de
l'Académie Royale, qui sont expo-
sés dans le Salon du Louvre.
invisible de dessin par gabriel de S. Aubin.

PEINTURES.

A bove: page from the Salon catalogue. Opposite: *Grapes and Pomegranates* (detail), shown at the Salon of 1763.

A bove: *Mercury in Love…* (detail) by Pierre from the Salon of 1763.

Monsieur Pierre

Monsieur Pierre, chevalier of the Order of the King, First Painter of His Grace the Duc d'Orléans and teacher at the Académie of painting, you no longer know what you are doing, and in that you are more at fault than other people. You are rich; you can easily afford beautiful models and make as many studies as you want. You don't have to wait for the money from a picture to pay your rent. You have all the time in the world to choose your subject, familiarize yourself with it, plan it and execute it. You had a better upbringing than the majority of your colleagues; you know the good French writers, you understand the Latin poets, so why not read them? They won't give you genius, that comes at birth; but they will move you, raise your thoughts to higher things, stir your imagination a little; you will find ideas in them that you can use.

On his return from Italy, Pierre exhibited a few pieces with good drawing and colouring technique, in fact they were quite striking, and well-handled, but we have had twenty years of all that. Where he used to set great

store by Guido, Correggio, Raphael, Veronese and the Carracci, today he calls their work daubs. He has been on the slide for ten years or more, and as his talent has dwindled, so his haughtiness has increased; he is now both the vainest and the dullest of our artists.

Vien, the novice

What a sad, dull job it is to be a critic! It is so hard to produce anything that is even mediocre, yet so easy to spot mediocrity! You're always sifting through the rubbish, like Fréron [a critic opposed to the philosophers] and the men who patrol our streets with handcarts. God be praised! Here is a man of whom one can say good things, almost without reservation. The most favourable image one could form of a critic is of one of those wanderers who set off, stick in hand, to rake the sandy bottoms of our river beds in the hope of discovering a speck of gold. Not a job for a rich man.

The pictures [Joseph Marie] Vien has exhibited this year are all of the same sort, and as they are all of roughly equal merit, they can all be praised in the same terms: for their elegance of form, their grace, ingenuity, innocence, delicacy and simplicity, all that accompanied by purity of line, beautiful colour and lifelike flesh tones.

Challe, the mediocre

Tell me, M. [Michel Ange] Challe, why are you a painter? There are so many other stations in life where mediocrity is a real advantage. It must be because a spell was cast over you in the cradle. You have been working at the job for thirty years now and you still have no idea what it is, and will no doubt die without ever finding out.

What a curious individual. He made the trip to Rome; there he saw quantities of old and beautiful pictures that everyone admired, and he said to himself: 'That's what you have to do to be admired like them.' And so he painted pictures which, though not beautiful, are certainly old.

Chardin, the model

After my child had copied and recopied this piece [*Jar of Olives*], I would set him

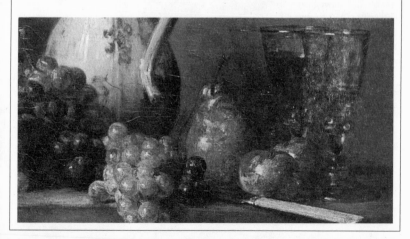

to work on *The Skate* by the same master. The subject is disgusting, but it is the very flesh, skin and blood of the fish; the appearance of the thing itself would affect you no differently. Monsieur Pierre, take a good look at this piece when you go to the Académie, and learn, if you can, the secret of using your talent to redeem what is disgusting about certain things in nature.

Vernet and *The Shepherdess of the Alps*

Madame Geoffrin, a woman well known in Paris, commissioned *The Shepherdess of the Alps, Subject of a Story by Marmontel*. I do not find either the story or the picture all that wonderful. The painter's two figures are neither arresting nor interesting. People enthuse about the landscape: they claim it is as awe-inspiring as the Alps viewed from a distance. Maybe, but that's an absurdity; for the figures, and for me sitting next to them, they are in fact very close; we are within touching distance of the mountain behind us, which is faithfully represented as a nearby mountain; only a narrow gorge separates us from the Alps. So why are the Alps undefined, the details indistinct, all greeny and hazy? To make up for his thankless subject, the artist has given his all to a large tree occupying the whole left-hand side of

An engraving showing the Salon of the Académie Royale de Peinture et de Sculpture (above).

the composition; most relevant! The point is that you should never give a specific commission to an artist, and when you want a fine picture in his style you should tell him: 'Do me a picture and choose whatever subject you like.' Or it would be simpler and more reliable to choose one he has already painted.

Desportes, the victim

[The subject is the nephew of Alexandre-François Desportes.]

He is a painter of fruit and one of Chardin's victims.

Guérin and Delaporte, an unknown and another victim

I know nothing of the former and there is not a soul alive who can tell you anything about him.... As for Roland de la Porte, he's another of Chardin's victims.

Greuze, 'my man'

Greuze really is my man. Leaving aside the small compositions that will give me plenty of pleasant things to say, I immediately go to his picture of *Filial Piety*, with the better title *The Rewards of Providing a Good Education*.

First, the genre appeals to me; it is a moral painting. Come on! surely the brush has for quite long enough concentrated on debauchery and vice? Should we not be pleased to see it at last competing with dramatic poetry in trying to touch us, instruct us, correct us and invite us to virtue? Courage, my friend Greuze, preach morality through painting. Stick to it!, so that when you

are on the point of leaving this life, there will be not one of your compositions you cannot recall with pleasure. Were you not at the side of that young girl contemplating the head of your *Paralytic*, who cried out with charming vivacity, 'Oh my god, I am so touched! but if I look at him again I think I shall cry.' Was this not my own daughter! I could recognize her from her reaction. When I saw that eloquent and moving old man, I, like her, felt my soul melt and tears spring to my eyes.

Parrocel: detestable?

The Holy Trinity. What the devil should one do with the Holy Trinity, unless of course one is Raphael?...

When I looked at this piece and I identified in it some drawing, a little bit of colour and, a lot of work, and I said: 'That is detestable.' I at once went on to say: 'Ah, painting, such a difficult art!'

Denis Diderot
Salon of 1763

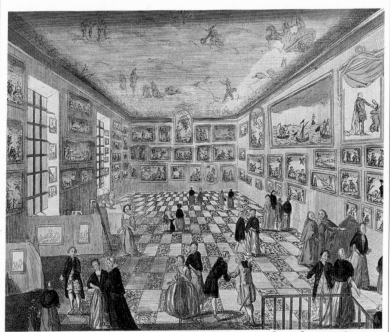

Vue perspective du Sallon de l'Académie Royale de Peinture et de Sculpture au Louvre à Paris.

An engraving showing the Salon of the Académie Royale de Peinture et de Sculpture.

Chardin and Diderot

The circumstances in which Chardin met Diderot are unknown. We do not even know if they really were friends, although it seems likely. From reading the philosopher's Salons *it is possible to imagine the conversations they must have had about art. What is certain is that the two men initiated a new sort of 'dialogue' between writer and painter, one that has become an integral part of French culture. Later examples include Baudelaire and Delacroix, and Malraux and Picasso.*

While the first reference to an acquaintanceship between Diderot and Chardin occurs in the entry for 'Copy' in the former's Encyclopédie *of 1754, it was not until 1759, in the first of his* Salons, *that the philosopher discussed the work of a painter whom he still addressed as Monsieur.*

M. Chardin has a good mind, he understands the theory of his art; he paints in a manner all his own, and one day his pictures will be sought after. He gives such breadth to his small figures that it is as if they were cubits tall. The breadth of execution is independent of the size of canvas and the scale of the objects. Reduce a *Holy Family* by Raphael as much as you want, and you will not destroy this breadth of execution.

Salon of 1759

Two years later, while reproaching the artist for his casual approach, he declares that 'there is possibly no one who speaks about painting better than he does'.

This painter has not finished anything for a long time; he can no longer be bothered with the hands and feet. He works like some society gentleman who has talent and ability, and is content to sketch out his ideas with a few strokes of the brush. He has placed himself in the vanguard of slapdash painters, and that after producing a large number of pieces that earned him an eminent position in the front rank of artists. Chardin has a quick mind, and there is possibly no one who speaks about painting better than he does. His reception piece in the Académie demonstrates his understanding of the magic of colour.

Salon of 1761

From 1763 onwards, Diderot was Chardin's champion, so inspired by the

Opposite: *Portrait of Diderot* by Fragonard.

painter's art that he held him up as an example to Jean-Baptiste Marie Pierre, First Painter to the King.

At the Salon there are several small pictures by Chardin; they are mostly of fruit with the accompaniments for a meal. It is nature itself; the objects stand out from the canvas and are so true that they deceive the eyes.

The one you see as you go up the stairs deserves particular attention. The artist has set on a table an old Chinese porcelain vessel, two biscuits, a jar full of olives, a bowl of fruit, two glasses half-filled with wine, a Seville orange and a pie.

If I wanted my child to be a painter, this is the picture I would buy. 'Make me a copy of this,' I would tell him, 'and then copy it again.' It is probably no more difficult to copy nature.

For this porcelain bowl is made of real porcelain; these olives really do look as if they are floating in water; these biscuits are just waiting to be picked up and eaten, this Seville orange to be split open and squeezed, this glass of wine to be drunk, this fruit to be peeled, this pie to be cut into.

He understands the harmony of colours and their reflections. Oh, Chardin, it is not white, red or black that you grind on your palette, it is the very substance of the subjects, it is air and light that you apply to the tip of your brush and transfer to the canvas.

Salon of 1763

If it is true that every connoisseur ought to own at least one Chardin, then let him have this one [*Dead Duck with a Pie, Porcelain Bowl and Jar of Olives*]: the artist is getting old. He has done some as good, but none better.

Salon of 1765

Chardin is such a rigorous imitator of nature, such a severe critic of himself, that I have seen one of his paintings of game that he never finished because the little rabbits he was copying had rotted away, and he despaired of achieving the harmony he had in mind if he used any others. All that were brought to him were too brown or too pale.

Salon of 1769

The last two years in which Diderot mentioned Chardin in his Salons were 1771 and 1775. He offered no account of those of 1773 and 1779. It is regrettable that he did not have more to say about the portraits in pastels.

It is still the same sure, free hand and the same eyes, accustomed to looking at nature, but examining it closely and teasing out the magic of its effects.

Salon of 1771

Saint-Quentin: These are some studies by Chardin that show sensitivity; the colouring is a little mannered. Generally, I do prefer his genre pictures.

Diderot: Why are you going so fast?

Salon of 1775

Masters?

Although Chardin was certainly taught by Cazes, it is hard to see what he retained from that teaching. While there is no direct evidence, it is probable that the knowledge and study of some old masters was a much more important influence. Although we do not know what paintings the young Chardin might have seen and admired, the 18th- and 19th-century critics were eager to offer their opinions.

T*he Kitchen Table* (detail, c. 1756).

'Monsieur Chardin's talent just harks back to the Le Nain brothers'

The prints engraved after works by Chardin were no less successful; they became all the fashion, and along with the prints of Teniers, Wouwerman and Lancret dealt the final blow to the serious prints of the Le Bruns, the Poussins, the Le Sueurs and even the Coypels of this world. The general public takes pleasure in seeing repeated the actions that take place in their homes every day right under their noses, and has no hesitation in preferring them to more exalted subjects, the appreciation of which, however, demands some sort of study. I have no wish to consider if that is detrimental to taste, and shall merely content myself with remarking that, if you think about it, Chardin's talent just harks back to the Le Nain brothers. Like them, he chooses the simplest and most naive subjects, and it must be said he makes the better choice. Attitudes and characters he captures very well and does not lack powers of expression. That in my belief has been the major factor to date contributing to the popularity of his pictures, winning them a place alongside Teniers and other Flemish painters who have worked in a similar genre, whatever the differences that may exist between their works and his.

Pierre-Jean Mariette
Abecedario, 1749

'Chardin has not imitated any other master'

Some works have no need of a number to indicate the master's name; among them are those by Chardin, the painter who renders nature most exactly and most truthfully.... His figures are drawn, lit and painted in the skilful

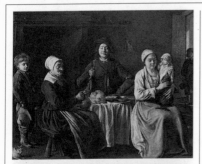

The *Happy Family* (top) and detail (above) by Louis Le Nain (1642).

and spiritual manner that he has made his own. Chardin has not imitated any other master but created for himself a distinctive manner that it would be perilous to try to copy.

In his paintings we find faithful colouring, precise drawing and the most spiritual imitation of nature; he renders its smallest details with all the patience of the Flemish painters, but his brush has the power of the best Italian masters.

Abbé Jean Bernard Le Blanc,
*Observations sur les
ouvrages de MM. de l'Académie*, 1753

'Dutch patience...and Italian genius'

Chardin's merit is universally recognized. The pictures by him on display at the Salon are worthy of the reputation he has won for himself in this genre of truthfulness in which he has long excelled. There is no collection in Europe where his works are not included in the ranks of the greatest masters. Dutch patience has not copied nature more faithfully, Italian genius has not rendered it with more rigour; what an astonishing thought that is for those given to such speculation. If you take twenty painters, they will all give a faithful account of nature, and yet each one in a manner that bears absolutely no resemblance to any other. Once one has learned to understand and appreciate these artistic mysteries, painting offers one of the finest sources of enjoyment.

Mercure de France
October 1761

'His first master was nature'

His first master was nature: he possessed from birth an understanding of chiaroscuro, and soon devoted himself to perfecting the rare talent he possessed, convinced that colour was everything in conveying the charm of the imitation, imparting to the thing imitated a special quality it often lacked in the real world.

'Eloge historique de M. Chardin'
Le Nécrologe des Hommes illustres,
vol. 15, 1780

In the 19th century, critics like Thoré, Champfleury, Jules and Edmond de Goncourt and Charles Blanc arrived at very similar conclusions.

'He is unique for turning his back resolutely on the fashion of his day'

Aelbert Cuyp, Adriaen Brouwer, Nicolaes Maes and Jan Fyt, those are the

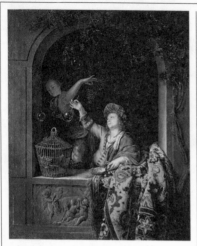

Above: *Soap Bubbles* by Willem van Mieris. Above right: *Soap Bubbles* (detail) by Chardin.

great practitioners with whom it is worth pointing out that Chardin's talent has certain analogies.

On top of that, he is unique for turning his back resolutely on the fashion of his day, brave man. The school of Watteau may churn out its sweet young girls who have nothing natural or expressive about them, and boudoir scenes that echo the easy morals of the time; Boucher may do marchionesses in a state of undress as nymphs and courtesans dressed up as shepherdesses, in landscapes that are stage sets for the Opéra; Chardin is different, he does not tie himself in knots to tantalize frivolous taste, or impress favourites, great lords and minor abbés. He stands so far outside contemporary feeling and style that artists like Largillierre at first took his pictures for works by foreigners imported from Flanders. Who in France at that time could have painted that magnificent picture of fruit, dishes and vessels…which the author submitted to the Académie as his reception piece? When you look at it, it is no surprise that Largillierre, with his memories of Antwerp, thought at once of Snyders. That was in 1728; Chardin was twenty-nine, and he had the good fortune to work for more than another half-century.

> W. Bürger (Thoré), 'Exposition de tableaux de l'Ecole française ancienne tirés des collections d'amateurs', *Gazette des Beaux-Arts*, 1860

Le Nain?

Le Nain never had Chardin's charm, nor did he seek it. Chardin is a cheery, mischievous fellow, who never in his life showed anything but amiability; he brings a certain elegance to the domestic scene. His mothers and children being scolded are very winsome in the way they are done. The children rarely cry, for the mother is not really cross. Life in these well-lit apartments seems a pleasure.

> Champfleury 'Nouvelles recherches sur la vie

et l'œuvre des frères Le Nain', *Gazette des Beaux-Arts*, 1860

'Of all the Flemish masters…Van der Meer'

And what originality in the enchantment of his tonality! In the case of Chardin, the painter has ancestors, not a master. He did not draw his inspiration from Van Mieris, or Ter Borch or Gérard Dou or Netscher or Teniers. Of all the Flemish masters, the only one he comes close to, purely by accident, is Metsu, in the soft, downy touch of his fichus and caps. In all the galleries of Europe I know of only one painting from which Chardin seems to be in a line of descent, and that is in the Six Collection, the admirable *Milk Woman* [*The Kitchen Maid*] by that varied and diverse master Van der Meer [Vermeer].

Jules and Edmond de Goncourt in *L'Art du dix-huitième siècle*, 1875

'The refinement of a French nature'

The Dutch painters like to take us into smoky bars where the local burghers puff away in melancholy silence or the sailors of the Zuider Zee brawl, drunk on strong beer; to the fidelity to life of the northern masters Chardin adds the refinement of a French nature. He discreetly introduces us into the workroom where the mother reprimands the lazy, forgetful little girl who has not done her embroidery; into the dining room where, with careful hand, she dispenses soup to her children; to where the governess recommends in vain the path of righteousness to the boy who prefers to follow his own path. If sometimes he moves from salon to antechamber, from bourgeois house to artisan's shop, his brush lends to the humblest of occupations an indefinable grace and honesty, a true distinction that is not to be found in the masters of the Low Countries.

Charles Blanc, 'Chardin' in *Histoire des Peintres*, 1862

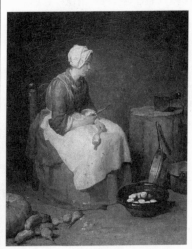

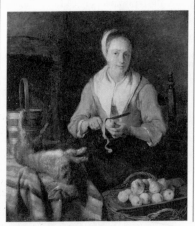

Left: *Woman Peeling Apples* by Gabriel Metsu (17th century). Above: *Woman Peeling Vegetables* by Chardin (1738).

The Goncourts: the revelation of Chardin's colour

The sale of the Marquis de Cypierre's collection in 1845 marked the beginning of the rediscovery of Chardin's oeuvre, but it was the Goncourt brothers who assured the artist his prominent position in the history of French painting. In 1863 and 1864, in the Gazette des Beaux-Arts, *they published a study of the painter, part of their project to rediscover 18th-century French art. Illustrated with engravings by Jules de Goncourt after Chardin paintings, their analysis, reprinted in 1875 in* L'Art du dix-huitième siècle, *represented the crowning achievement of twenty years of research on the painter.*

'That nameless colour'

He scarcely bothers to compose his picture, simply puts down the truth.... Just a silver goblet and some fruit, nothing more, and that suffices to make an admirable picture. The sheen and sparkle of the goblet is achieved with just a few scratched touches of white in dry pigment; the shadows contain every sort of tone, every sort of colour, threads of a blue that is almost violet, streaks of red that are the reflection of the cherries on the goblet, a blurred, almost smudged browny red in the shadow of the pewter metal, tiny spots of yellowy red playing among dabs of Prussian blue, a permanent reminder of all the ambient colours glancing over the polished metal of the goblet.

Study another of his pictures that is equally simple, equally full of light and harmony: this one is a glass of water with two chestnuts and three walnuts; study it for a good while, then retreat a few paces, and the glass is thrown into relief, there is glass and there is water, there is that nameless colour that comes from the transparency of contents and container. On the surface of the water, at the bottom of the glass, daylight itself plays, quivers and fades. Ranges of the softest colours, the most subtle variations of blue turning to green, an infinite modulation of a certain sea-green grey, crystalline and vitreous, the touch always broken, gleams of light kindling in the shadows, highlights left like fingermarks on the side of the glass, that is all you see when you are close up to the canvas. Here, in this corner, there is just a muddy daub, the mark of a brush being cleaned, but then out of this mud a walnut emerges, curled inside its shell, showing all its curves, displaying every detail of its form and colour....

'Scarcely a hint of pink…a suggestion of violet…a trace of red'

I remember an early sketch of *The Household Accounts*, a woman seated by a window with a green curtain. Against a brown background with rough textured brushwork, the loaded brush, saturated with white, following the folds of the garment's pleats, twisting and blotting itself out against the elbow and the turn-ups of the sleeves, leaving trails of dry impasto on the highlights, has created an excellent rough draft, with nothing but white and dirty grey; scarcely a hint of pink on the face and hands, a suggestion of violet on a ribbon, a trace of red on the trimmings of the dress; and yet there is a face, a dress, a woman, and all the picture's final harmony is there at the dawning of its colour. Another sketch by him I have seen, *House of Cards*, is the opposite, it sparkles and sizzles; it is all noise and show, freshness and vivacity. The glazes are as shiny as enamel; the whole gamut of tones is modulated in the sheen of amber and burnt topaz.…

'The cap…that is…nothing but blue'

Go and see the two portraits in the Louvre in which he has represented himself as the old grandfather presiding over his oeuvre, unadorned, in the shabby, informal undress of a bourgeois septuagenarian, wearing a nightcap, eye-shade on forehead, spectacles on nose, mazulipatam scarf round the neck; such surprising images! The violent and temperamental execution, the pounding, the hammering, the dabbing and the slashing, the build-up of chalk, those big crude disjointed strokes, the daring to match tones that are unmatchable, to put the raw colour straight down on the paper, those base colours that are like those the scalpel uncovers beneath the skin, all that fuses and fits together, at a distance of a few paces, takes shape, lights up, and suddenly it is flesh you are looking at, live flesh.…

The weathering of the cheeks, the blue shadow of the wizened beard, the whites, pinks and soft tints, that humid gleam that swims in the eye and bathes the facial expression, Chardin achieves all of these; he expresses the truth and the illusion of flesh and blood with strokes of bright red, pure blue and golden yellow, in unadulterated primary colours that you would think would exaggerate life and strain the appearance of reality.…

And yet that is not his masterpiece. It is in the portrait of his wife that he reveals all his fire, all the power of his eloquence.… How do you capture the secret, how define the substance of that toothless mouth that twists, puckers, purses and breathes, that has all the infinite delicacy of line, curve and inflexion of a real mouth? All it apparently consists of is a few traces of yellow and a few sweeps of blue. The shadow cast by the cap, the light on the temple filtered by the linen, that transparency gleaming around the eyes, what is that? Streaks of pure reddish brown, broken with a few strokes of blue. And the cap itself that is absolutely white and nothing but white, that is blue and nothing but blue. And the white of the face is done with pure yellow: for there is no white in this clear face; just three dabs of crayon on the whole of the head, where the light hits the tip of the nose and the light in the two eyes. Painting everything its true colour, without painting anything in its true colour, that is the tour de force, that is the miracle this colourist has achieved.

Edmond and Jules de Goncourt
L'Art du dix-huitième siècle, 1875

The notion of truth in Chardin's work

'The pictures by him on display at the Salon are worthy of the reputation he has won for himself in this genre of truthfulness in which he has for so long excelled,' read the Mercure de France in October 1761. 'He cannot make a brushstroke that is not in the service of truth. One senses that truth loves this painter whose loyalty to it is so fierce,' wrote Julien Green in 1949. Whether contemporary with the artist or posthumous, critiques of Chardin's painting almost all refer to the truthfulness of his works, to the point that this quality becomes their defining characteristic.

The term 'truth' or 'truthfulness' is so vague it could equally be applied to a number of other painters, especially in the genre of still life where the idea of faithful imitation seems fundamental. Yet Chardin's works have their own sort of truth, one which opens up questions about the nature of painting and the motivation of the artist.

In antiquity, it is said that the mystic Zeuxis painted grapes so well that the birds were completely taken in and tried to peck them. In the 18th century, if we are to believe Diderot in his *Salon* of 1763, Chardin surpassed him: 'Ah, my friend, spit on Apelles's curtain and the grapes of Zeuxis. It is easy to deceive an impatient artist and animals are poor judges of painting. Haven't we seen the birds in the king's gardens crack their heads against the worst perspectives? When Chardin sets his mind to it, it is you and me he will deceive.'

Diderot does not expand on his theme but does at least identify the type of truthfulness at which Chardin excelled as one connected with the appearance of things. Zeuxis's grapes were literally trompe-l'oeil creations, designed to deceive the eye. The trompe-l'oeil practised by Oudry in Chardin's day was directed to the same end; the painter places an object in the foreground and, by making it stand out from its painted background, by painstakingly rendering its minutest details, gives it an extraordinary relief that is capable of creating the illusion. It is relevant to note that the only trompe-l'oeil canvases by Chardin – the grisaille bas-reliefs – were copies of sculptured friezes. Chardin's composition adopted the format of the original sculpture, without altering the background or setting. The grisaille

bas-reliefs therefore declare themselves openly for what they are: copies of sculptures, nothing more.

With Chardin's still lifes, no bird would ever try to peck the fruit or fly down some false perspective, for Chardin employs neither perspective nor trompe-l'oeil. In the earlier large-scale compositions like *The Skate* and *The Buffet*, the objects still occupy several planes within the picture. They are also organized around a central mass, usually a pyramid, which is the first thing to attract our attention; in the former this is the fish, in the second the pile of fruit. However, the painter rapidly abandoned these complicated compositions, his increasing desire for a more stripped down canvas no doubt encouraged by his difficulty in representing a number of different spatial planes, something we can see very clearly in his genre scenes. When Chardin reverted to still life, he made no attempt to place the elements of his composition in perspective. In *Jar of Olives* or *The Brioche*, the objects are set well forward on the canvas and more or less in line, forming a sort of frieze.

'When Chardin sets his mind to it, it is you and me he will deceive'

The human gaze is not programmed in the same way as an animal's to react only to stimuli. It may for an instant be deceived by an optical illusion, but it is only for an instant. That presumably is why, unlike certain of his contemporaries, Chardin did not use trompe-l'oeil: his aim was not to make an illusion but to re-create the living, moving character of the vision of reality.

Chardin's art appears more 'true' than many others because he captures the palpable unity of a group of objects or people, the subtle relationship that binds things and figures together, and he roots them in a particular atmosphere and colour.

'When Chardin sets his mind to it…he will deceive,' says Diderot. The point is that the painter has not set his mind to it, and the use of the future tense confirms that the reference is to something yet to happen.

Ever since antiquity the purpose of the still life has been to trick the viewer, while ever since the Renaissance pictorial space has been organized according to the laws of perspective. Chardin forges a new path by renouncing both procedures, which he presumably judged peripheral to painting, seeking to capture instead the live interaction of the spectator's gaze with the reality of the world.

In one sense, but one sense only, Chardin's unifying vision prefigures what the Cubists attempted a little under two centuries later, when they brilliantly demonstrated that the human gaze is never restricted to a single point of view of a thing, but always sees it from a number of different angles and reconstructs it as it chooses. 'When we invented Cubism,' Picasso said, 'we had no intention of inventing Cubism, only of expressing something inside ourselves.' Because Chardin had no aptitude for the major genre, he was expressing something inside himself. He painted what lay before his eyes. He did it discreetly, in the privacy of his studio, with no reference to any particular theory. Even then, he personified the image of the modern artist, whose work is a form of personal exploration, undertaken alone and without outside help.

Hélène Prigent and Pierre Rosenberg

Artists and writers

Chardin has inspired not only great painters like Lucian Freud and the Italian master of still-life objects, Giorgio Morandi, but also modern French writers such as Francis Ponge and Gérard Titus-Carmel, as well as the legendary Proust, who wrote to Madame de Pierrebourg in June 1913: 'I remember that after Chardin had taught me that the humblest of things, a tablecloth, a knife or a dead fish can be beautiful, Veronese taught me that beautiful things are not exempt from that potential for beauty and that gold, silks and jewelry can be beautiful in the same way as a knife and a tablecloth.'

In 1895 Proust wrote a study of Chardin, which was never published in his lifetime. The following year, in a letter to Pierre Mainguet, he spoke of it as follows: 'I try to show his influence on our life, the charm and wisdom it imparts to the humblest of our days as he introduces us to still life.'

Marcel Proust, 1895

If it all now seems beautiful to look at, it is because Chardin found it beautiful to paint. And he found it beautiful to paint because he found it beautiful to look at. The pleasure you derive from his painting of a sewing room, an office, a kitchen, a buffet, is – captured in passing, detached from the moment, deepened and eternalized – the same pleasure he derived from the sight of a buffet, a kitchen, an office or a sewing room.... Seeing him confide to you the secrets he knows about them, they will no longer hold back from confiding them to you directly. Still life now becomes living nature. Like life, it will always have something new to say to you, some glorious thing to illuminate, some mystery to reveal; everyday life will charm you, once you have absorbed his painting for a few days, like a lesson; then, having understood the life of his painting, you will have discovered the beauty of life.

Into [those] rooms where you see only the image of the ordinary life of other people and the reflection of your own boredom, Chardin enters like a shaft of light, giving to each thing its colour, awakening from the eternal night in which they were shrouded all the elements of still life or life studies, each form of shining significance for the eye, if obscure significance to the brain. As in *The Sleeping Beauty*, every one of them springs to life, acquires colour, starts to talk to us, to live and to endure.

Marcel Proust, 'Chardin au coeur
des choses',
Le Figaro littéraire, 1954

Giorgio Morandi, 23 June 1956

As you might have expected, the
Chardins in the small salon [of the
Oskar Reinhart collection] appealed
to him the most. He showed particular
interest in *The House of Cards*, paying
special attention to the position of the
cards. He also studied carefully the still
life with glass of water and basket of
peaches, but took little notice of the
small Watteau and the Ingres drawing.

Heinz Keller
in the catalogue *Morandi*,
1990

Alberto Giacometti, 1962

Art and science are all about trying to
achieve understanding. Failure and
success are entirely secondary. It is a
recent adventure, starting around the
18th century with Chardin, when
artistic vision began to be seen as more
important than serving the church
or impressing the king. People were at
last left to their own devices!

Alberto Giacometti, 'Entretien avec
André Parinaud',
Arts, no. 873, 13–9 June 1962

Francis Ponge, 1963

Chardin holds an admirable line
between calm and inevitability.

I myself am the more susceptible
to the inevitability because it proceeds
at an even pace, with no demonstrative
outbursts, as a matter of course....
When everything falls back into place,
with no fuss, in the light of destiny.

That is also why even the most minor
still life is a metaphysical landscape.

Perhaps it all springs from the fact
that human beings, like every creature

of the animal kingdom, are in some
sense superfluous to nature: sort of
vagrants who spend their days seeking
a place to lay their heads at last, a place
to die.

That is why he attaches such
importance to space, which is where he
roams and strays and zigzags on his way.

That is why the most insignificant
arrangement of things, in the smallest
fragment of space, fascinates him....
Certainly, time passes, but nothing ever
happens. It is all there.

Francis Ponge
'De la nature morte et de Chardin',
Art de France, 1963

Titus-Carmel, 1994

In this picture, in the profanation of the
skate (and, in order to represent its sheer
expanse, of painting, itself profaned and
laid bare) there is an expiatory element
that acts as an anaesthetic. Otherwise,
what would it mean, all this slashed flesh
immodestly displayed…this marine
fauna, caught, skinned, eviscerated and
set out as though on an altar, where
what are clearly the symbols of some
recently celebrated mass transport us
to the end of a ceremony from which
enjoyment seems to have been curiously
absent?

Gérard Titus-Carmel
Premier sang, 1994

Lucian Freud, 1995

Now I realize Chardin must have used
burnt umber. But I had never, ever
thought about this, because it's in the
nature of his work.... Even as a painter,
I'm not technically aware of what he is
doing, any more than you notice the
vocal timbre of someone who is telling
you something that is very important.

Lucian Freud, *International Herald
Tribune*, December 1995

Cézanne and Chardin

Cézanne was one of several artists who studied Chardin's work. In a letter to Emile Bernard of 27 June 1904 discussing Portrait of Chardin with Spectacles, *he speaks of the painter in terms that suggest a long familiarity with his work: 'He's a sly old devil, this painter. Haven't you noticed how, at the top of his nose, he sets the bridge in a slightly angled plane, and how that helps with keeping the values? Have a look at it for yourself and tell me if I'm not right.' In an article about the two painters, the American art historian Theodore Reff offers the first detailed analysis of the possible influence of Chardin's painting on Cézanne.*

It would be hard to imagine the emergence of still life as a major category of modern art without the example of Cézanne from about 1875 on, and equally hard to imagine his achievement without the revival of Chardin some thirty years earlier....

Cézanne's only known copy after Chardin, a notebook sketch made about 1890 after *The Skate*, reproduces a small area at the lower right showing a few kitchen utensils....

About his interest in Chardin, then, Cézanne's copy tells us only that he admired that master sufficiently to stop before one of his works (an early, atypical work at that) and to make a sketch of it.

The fullest evidence of what Cézanne saw in and learned from Chardin is indeed in his paintings – and not exclusively in his still lives, as one might assume. The self-portrait of Chardin that Cézanne recalls in his letter, vividly enough to suggest that it has made a strong impression, may also have been the model for one of his own self-portraits. The proportions of the field, the placement of the figure within it, the turn of the body and opposite turn of the head, the deeply serious gaze with one eye nearly centered – these are very similar in the two works. Both also depict the artist as a 'bon bourgeois', sober and solid, conservatively dressed in a jacket and scarf, yet unselfconsciously wearing for warmth a cap improvised from a napkin or towel. For all the extravagance of his early bohemian years, by the time Cézanne painted this self-portrait about 1880 he had become, at least in appearance and behavior, the type of 'peintre bourgeois de la bourgeoisie' [bourgeois painter of the bourgeoisie] that the Goncourts had seen in Chardin, 'la bourgeoisie de peine

et de travail, heureuse dans sa paix, son labeur et son obscurité' [the middle-class of effort and work, happy in its peace, its labor and its obscurity].

From *The House of Cards* to *The Cardplayers*

Some thirty years later, Cézanne seems again to have recalled a well-known figure painting by Chardin in planning one of his own: the cardplayer at the left in the four- and five-figure versions of *The Cardplayers*, painted from 1890 to 1892, is remarkably similar to the one in the Louvre's *House of Cards* in the forward slant of his torso, the careful gestures of his hands, the inwardness of his expression, even the hat that draws attention to his mental concentration. The resemblance is still more apparent in one of Cézanne's watercolor studies for the composition, where this player is isolated from the others. But since the study was clearly made from life, probably from a farmworker posing at the Jas de Bouffan [a property acquired by Cézanne's father], the significance of the resemblance changes: at most one can assume that Cézanne, who had undoubtedly seen the Chardin in the Louvre, remembered it or relied on a reproduction of it in posing his peasant model. The same can be said of the model he used for the cardplayer across the table, as is again particularly evident in the watercolor study; in all the same respects, including the positions of the arms and hands, it resembles another version of the *House of Cards*.

In choosing this inward, self-contained pose for both cardplayers, as well as for the third player and the spectators, Cézanne endows the subject, traditionally an occasion for boisterous or conniving behavior, with the gravity and mystery of a sacred ritual. The same

sense of stillness and timelessness informs Chardin's genre pictures. What Pierre Rosenberg says of them could as well be said of Cézanne's: 'Fuyant les éclats, [il] place ses scènes hors du temps, qui prennent, de ce fait, une valeur éternelle.... Les visages sont sans individualité, sans expression aussi. Aucun mouvement ne vient troubler ses compositions...' [Shunning flashy effects, (he) sets his scenes in timeless settings, thus giving them an unchanging value.... The faces are without individuality and also without expression. No movements appear to disturb his compositions...]. But beneath this timeless aspect, there is in both cases a time-bound, cultural reality: both artists choose as models ordinary people of the lower middle-class, and both show them absorbed in their daily labors and pleasures with great simplicity and naturalness. The cardplayers, smokers and peasants in Cézanne's world, like the mothers, servants and children in Chardin's, display an inherent poise and dignity, although Cézanne's are sometimes more impersonal in their strict frontality and symmetry. Clearly, both artists admired and even identified themselves with these largely anonymous figures: more than convenient models, they were congenial human types.

Theodore Reff
in *Cézanne aujourd'hui*, 1997

CHRONOLOGY

1699 2 November: birth of Jean Siméon Chardin in the Rue de Seine, Paris, the son of Jean Chardin and Jeanne Françoise David. Baptism the following day at Saint-Sulpice
- **1715** Death of Louis XIV
- **1715–23** Philippe, Duc d'Orléans, governs as regent

1718–28 Chardin taught by Pierre-Jacques Cazes (1676–1754), then Noël-Nicolas Coypel (1690–1734)

pre-1720 Chardin family moves to the corner of Rue du Four and Rue Princesse

1723 6 May: first marriage contract between Marguerite Saintard and Chardin
- Death of Duc d'Orléans. Louis XV's official reign begins

1724 3 February: Chardin received as master painter by the Académie de Saint-Luc
- **1725** Marriage of Louis XV and Maria Leszczyńska

1728 27 May: Chardin exhibits at the Place Dauphine various paintings, including *The Skate* and *The Buffet* (both Louvre). 25 September: Chardin accepted and received on the same day by the Académie Royale de Peinture et de Sculpture, as a painter 'with a talent for animals and fruit'

1729 5 February: resigns membership of the Académie de Saint-Luc

1731 1 February: wedding of Chardin and Saintard at Saint-Sulpice. 2 April: death of Chardin's father. 18 November: baptism of Jean-Pierre Chardin, the couple's elder son

1732 Chardin exhibits at Place Dauphine

1733 Chardin paints his first pictures with figures. 3 August: baptism of first daughter Marguerite Agnès Chardin, who dies young

1734 Chardin shows sixteen paintings at the Salon de Jeunesse, Place Dauphine, among them *Lady Sealing a Letter* (Berlin)

1735 13 April: death of first wife Marguerite Saintard

1737 Reopening of the Salon. Chardin exhibits seven works, among them *The Washerwoman* (Stockholm)

1738 Chardin shows nine paintings at the Salon, among them *Child with a Spinning Top* (Louvre) and two versions of *The Draughtsman* (Louvre and Stockholm). The first print after one of his pictures goes on sale

1739 Chardin shows six paintings at the Salon, including *Lady Taking Tea* (Glasgow) and *Girl Returning from the Market* (Ottawa)

1740 Chardin exhibits five paintings at the Salon, including *Saying Grace* (Louvre). Presented to Louis XV at Versailles, he gives the painting to the king as a gift, together with *The Diligent Mother* (Louvre)
- Accession of Frederick the Great, King of Prussia

1741 Chardin exhibits at the Salon *The Morning Toilet* (Stockholm) and *House of Cards* (National Gallery, London)

1742 Chardin submits no paintings to the Salon

1743 Death of Chardin's mother. The painter shows three paintings at the Salon. Appointed council member of the Académie Royale de Peinture et de Sculpture

1744 1 November: contract of marriage between Chardin and Françoise Marguerite Pouget, widow. 26 November: marriage at Saint-Sulpice. Chardin moves to 13 Rue Princesse

1745 Commissioned to paint two works for Louisa Ulrica, Princess Royal of Sweden. 21 October: birth of Angélique Françoise Chardin, who dies the following year in Nogent-le-Roi
- Le Normant de Tournehem is appointed Directeur Genéral des Bâtiments du Roi
- Start of Madame de Pompadour's reign of influence

1746 Chardin shows four paintings at the Salon, two genre scenes and two portraits

1748 As in 1747, Chardin submits only one painting, *The Drawing Lesson*, to the Salon (now biennial)
- Treaty of Aix-la-Chapelle to bring peace at the end of the War of Devolution (1668) and the War of Austrian Succession (1748)

1751 Chardin again shows only one painting at the Salon, *The Bird Organ* (Louvre)
- Publication of the first volume of Diderot's *Encyclopédie*

1752 The king pays 1500 livres for *The Bird Organ* and gives Chardin an allowance of 500 livres

1753 Chardin submits nine paintings to the Salon

1754 Jean-Pierre Chardin wins first prize in painting at the Académie
- The Marquis de Vandières (Marigny), brother of Madame de Pompadour, is appointed Directeur Genéral des Bâtiments du Roi
- Work begins on the Place Louis XV (now Place de la Concorde) by Jacques-Ange Gabriel

1755 Chardin is unanimously elected treasurer of the Académie
• Birth of the future Louis XVIII
1756 Chardin reverts to still-life painting. An engraving of Chardin's portrait by Laurent Cars, after the drawing by Cochin, goes on sale
• **1756–63** Seven Years' War of Britain and Prussia against France and Austria
1757 The king grants Chardin lodgings in the galleries of the Louvre (occupied previously by the king's goldsmith François Joseph Marteau). The painter exhibits six works at the Salon. Jean-Pierre Chardin forfeits right to much of his mother's inheritance and leaves Paris for Italy
1759 Chardin exhibits nine paintings at the Salon, including seven still lifes. This is the first Salon described by Diderot
1760 Quentin de la Tour executes a portrait of Chardin in pastel (Louvre). Chardin paints *Jar of Olives* (Louvre) and *The Cut Melon* (private collection)
1761 Following the death of Jacques André Portail, Chardin is appointed to oversee the hanging of the Salon. He exhibits at least eight of his own paintings, including possibly *Vase of Flowers* (Edinburgh) and *Basket of Wild Strawberries* (private collection)
1762 Jean-Pierre Chardin abducted by pirates
• Catherine the Great becomes Empress of Russia
1763 Cochin requests a further allowance for Chardin from the king. The painter shows at least six works at the Salon, among them *The Brioche* and *Jar of Olives* (both Louvre), described by Diderot in glowing terms. Chardin is commissioned by the king to execute three overdoors for the Château de Choisy, each for 800 livres. He completes them the following year
• The Treaty of Paris brings the Seven Years' War to a close
1765 Chardin is received by the Académie of Rouen. He shows at least eight works at the Salon, including the three overdoors for the Château de Choisy and *The Basket of Grapes with Three Apples, a Pear and Two Marzipans* (Angers). Diderot praises the painter's work at length

1767 Chardin exhibits only two pictures at the Salon, two overdoors commissioned for the Château de Bellevue
1768 At Cochin's suggestion, Chardin is granted an increase of 300 livres in his pension following the death of Jean Bernard Restout
1769 Chardin exhibits nine paintings at the Salon. He is known to be unwell
1770 Following Boucher's death, Cochin obtains a further pension of 400 livres for Chardin
• Marriage of the Dauphin, the future Louis XVI, to Marie-Antoinette
1771 Jean-Baptiste Marie Pierre is appointed First Painter to the king and director of the Académie. Chardin shows four oil paintings and a number of pastels at the Salon
1772 Suicide of Chardin's son
1773 Chardin exhibits one oil painting and one pastel at the Salon. Because of illness, the painter is obliged to take out an annuity against his house at Rue Princesse
• The Comte d'Angiviller replaces Marigny as Directeur des Bâtiments du Roi
1774 Chardin leaves his post as treasurer of the Académie. Vien takes charge of hanging the Salon and Coustou is appointed treasurer
• Death of Louis XV. Accession of Louis XVI
1775 Chardin exhibits three pastel 'studies of heads' at the Salon
• 4 July: Declaration of Independence by the United States from Britain
1777 Chardin tries to use his influence to restore Cochin's reputation. He exhibits three pastels and one oil painting at the Salon
1779 For the last time Chardin exhibits at the Salon 'several studies of heads in pastel'. The critics are not impressed, but are indulgent towards the 'indefatigable old man'. 25 September: Chardin attends a meeting at the Académie. 16 November: Doyen writes to Desfriches explaining the painter is gravely ill. 6 December: Chardin dies in his lodgings at the Louvre, and is buried the following day at Saint-Germain-l'Auxerrois. His death arouses little comment
• **1780** 6 March: Chardin sale at the Hôtel d'Aligre

FURTHER READING

EXHIBITION CATALOGUES

Cavalli-Bjorkman, Görel, and Bo Nilson, *Stilleben*, Nationalmuseum Stockholm, 1995
Louboutin, Catherine, and Annie Scottez, *Au temps de Watteau, Fragonard et Chardin. Les Pays-Bas et les peintres français du XVIIIe siècle*, Musée des Beaux-Arts, Lille, 1985
Rosenberg, Pierre, and Sylvie Savina, *Chardin*, Grand Palais, Paris, 1979 and 1999

— et al, *Chardin*, Grand Palais, Paris, 1999

SELECT BIBLIOGRAPHY

Conisbee, Philip, *Chardin*, 1986
Roland Michel, Marianne, *Chardin*, 1996
Rosenberg, Pierre, *Chardin*, 1991
— *Tout l'oeuvre peint de Chardin*, 1983
Wildenstein, Georges, *Chardin*, revised and enlarged by Daniel Wildenstein, 1969

LIST OF MUSEUMS

CANADA

Ottawa, National Gallery of Canada
Toronto, Art Gallery of Ontario

FRANCE

Amiens, Musée de Picardie
Angers, Musée des Beaux-Arts
Avignon, Angladon-Dubrujeaud Foundation
Bordeaux, Musée des Beaux-Arts
Carcassonne, Musée des Beaux-Arts
Chartres, Musée des Beaux-Arts
Cherbourg, Musée Thomas Henry
Douai, Musée de la Chartreuse
Lille, Musée des Beaux-Arts
Paris, Louvre
Paris, Musée Cognacq-Jay
Paris, Musée de la Chasse et de la Nature
Paris, Musée des Arts Décoratifs
Paris, Musée Jacquemart-André
Rennes, Musée des Beaux-Arts

GERMANY

Berlin, Stiftung Preussische Schlösser und Gärten
Frankfurt, Städelscher Museumsverein
Karlsruhe, Staatliche Kunsthalle
Munich, Bayerische Staatsgemälde Sammlungen

IRELAND

Dublin, National Gallery of Ireland

RUSSIA

Moscow, Pushkin Museum
St Petersburg, Hermitage

SPAIN

Madrid, Thyssen-Bornemisza Foundation

SWEDEN

Nationalmuseum, Stockholm

UNITED KINGDOM

Edinburgh, National Gallery of Scotland
Glasgow, Hunterian Art Gallery
London, National Gallery

UNITED STATES

Detroit, The Detroit Institute of Arts
Fort Worth, Kimbell Art Museum
Houston, Blaffer Foundation
Indianapolis, Indianapolis Museum of Art
Los Angeles, Los Angeles County Museum of Art
Minneapolis, Minneapolis Museum of Art
New York, The Frick Collection
New York, Metropolitan Museum of Art
Philadelphia, Philadelphia Museum of Art
Pittsburg, Carnegie Museum of Art
Saint Louis, Saint Louis Art Museum
Springfield, Museum of Fine Arts
Washington, D. C., National Gallery of Art
Washington, D. C., The Phillips Collection

LIST OF ILLUSTRATIONS

The following abbreviations have been used:
a above; *b* below; *c* centre; *l* left; *r* right; BN
Bibliothèque Nationale, Paris; Louvre Louvre,
Paris. *All works are by Jean Siméon Chardin unless
otherwise stated.*

COVER

Front *The House of Cards* (detail), Salon of 1737.
Oil on canvas, 82 × 66 cm (32¼ × 26 in.).
Andrew W. Mellon Collection, © 1999 Board of
Trustees, National Gallery of Art, Washington, D.C.
Spine *Girl Returning from the Market* (detail),
1738. Oil on canvas, 46.7 × 37.5 cm (18⅜ × 14⅞
in.). National Gallery of Canada, Ottawa
Back *Tinplated Copper Cauldron, Pepper Mill,
Leek, Three Eggs and a Casserole*, c. 1733. Oil on
wood, 17 × 21 cm (6¾ × 8¼ in.). Louvre

OPENING

1 *The Attributes of the Arts and Their Rewards*
(detail), 1766. Oil on canvas, 112 × 140.5 cm
(44⅛ × 55⅜ in.). Hermitage, St Petersburg
2 *The Young Draughtsman* (detail), 1737. Oil on
canvas, 80 × 65 cm (31½ × 25⅝ in.). Louvre
3 *Girl with a Shuttlecock* (detail), Salon of 1737.
Oil on canvas, 81 × 65 cm (31⅞ × 25⅝ in.).
Private collection, Paris
4–5 *Lady Taking Tea* (detail), 1735. Oil on
canvas, 80 × 101 cm (31½ × 39¾ in.). Hunterian
Art Gallery, University of Glasgow
6 *Girl Returning from the Market* (detail), 1739.
Oil on canvas, 47 × 38 cm (18½ × 15 in.).
Louvre
7 *The Smoker's Box* or *Pipes and Tumbler*, c. 1737.
Oil on canvas, 32.5 × 42 cm (12⅞ × 16½ in.).
Louvre
8–9 *Vase of Flowers* (detail), c. 1755–60? Oil on
canvas, 44 × 36 cm (17⅜ × 14⅛ in.). National
Gallery of Scotland, Edinburgh
11 *Duck with Seville Orange*, c. 1729–30. Oil on
canvas, 80.5 × 64.5 cm (31¾ × 25½ in.). Musée
de la Chasse et de la Nature, Paris

CHAPTER 1

12 *Self-portrait*, also known as *Portrait of Chardin
with Spectacles*, 1771. Pastel, 46 × 37.5 cm (18⅛ ×
14⅞ in.). Louvre
13 Chardin's signature

14a Gabriel de Saint-Aubin. *Portrait of Charles-
Nicolas Cochin.* Engraving. BN
14–5 Extract from the text by Charles-Nicolas
Cochin 'Essai sur la vie de M. Chardin'.
Bibliothèque Municipale, Rouen
14b Gabriel de Saint-Aubin. *Portrait of Pierre-Jean
Mariette.* Engraving after Charles-Nicolas Cochin.
BN
15 Charles-Nicolas Cochin. *Portrait of Chardin*,
1755. Black lead and stump on vellum, diameter
11.5 cm (4⅝ in.). Louvre
16a Charles-Nicolas Cochin. *The Print Collectors.*
Engraving. BN
16c Extract from the Salon catalogue of 1753.
BN
16b *Servant Filling a Player's Glass* (detail),
1722–4. Red chalk, black chalk and white
highlights on grey-brown paper, 24.7 × 37 cm
(9⅝ × 14⅝ in.). Nationalmuseum, Stockholm
17 *Game of Billiards*, c. 1722–4. Oil on canvas,
55 × 82.5 cm (21⅝ × 32½ in.). Musée Carnavalet,
Paris
18 Joseph Aved. *Portrait of Pierre-Jacques Cazes*,
1734. Musée National du Château, Versailles
18–9 Jules de Goncourt. *The Surgeon's Signboard.*
Engraving after lost oil sketch by Chardin. BN.
19c *Male Nude* (verso of *The Vinaigrette*). Black
chalk with white highlights on grey-brown paper,
28.7 × 40.6 cm (11¼ × 16 in.). Nationalmuseum,
Stockholm
19b *The Vinaigrette*, 1720–2. Black chalk with
white highlights on grey-brown paper, 28.7 × 40.6
cm (11¼ × 16 in.). Nationalmuseum, Stockholm
20al *Lady Taking Tea*, 1735. Oil on canvas,
80 × 101 cm (31½ × 39¾ in.). Hunterian Art
Gallery, University of Glasgow
20ar Signatures of Marguerite Saintard and Jean
Siméon Chardin on their marriage contract, dated
6 May 1723. Archives Nationales, Paris
20–1 C. L. van Grevenbroeck. *Paris Seen from
Above the Pont Royal*, c. 1738. Oil on canvas.
Musée Carnavalet, Paris
21a Extract from the register of best painters at
the Académie Royale de Peinture et de Sculpture
for the year 1757. Archives Nationales, Paris
21b Laurent Cars. *Portrait of Françoise Marguerite
Pouget*, 1755. Engraving after C.-N. Cochin. BN
22 Anonymous. *Jean-Pierre Chardin Copying a
Drawing*, 18th century. Drawing, French school.
EVB collection, London
23 Charles-Nicolas Cochin. *The Life Drawing*

Session, 1775. Drawing. Location unknown

24 Pierre-Denis Martin. *Assembly of the Académie de Peinture et de Sculpture at the Louvre*, c. 1712–21. Oil on canvas, 40.3 × 42 cm (15⅞ × 16½ in.). Louvre

24–5 Chardin's nomination as treasurer of the Académie. Extract from the registers of the Académie Royale de Peinture et de Sculpture, 22 March 1755. Archives Nationales, Paris

25 Maurice Quentin de la Tour. *Portrait of Chardin*, 1760. Pastel. Louvre

26 *House of Cards*, also known as *Son of M. Le Noir Building a House of Cards*, c. 1737. Oil on canvas, 60 × 72 cm (23⅜ × 28⅜ in.). National Gallery, London

27 *Child with a Spinning Top*, c. 1737. Oil on canvas, 67 × 76 cm (26⅜ × 29⅞ in.). Louvre

28 (detail) and **29a** (detail showing works by Chardin) Gabriel de Saint-Aubin. *The Salon of 1765*. Watercolour. Louvre

28–9 and **29b** Extract from an article on the Salon of 1761. *Mercure de France*, June 1761

30l *The Amusements of Private Life*, 1746. Oil on canvas, 42.5 × 35 cm (16¾ × 13¾ in.). Nationalmuseum Stockholm

30r *The Morning Toilet*, 1741. Oil on canvas, 49 × 39 cm (19¼ × 15⅜ in.). Nationalmuseum, Stockholm

31 Joseph Aved. *Portrait of Carl Gustaf Tessin* (detail), c. 1740. Oil on canvas, 149 × 116 cm (58⅝ × 45⅝ in.). Nationalmuseum, Stockholm

32l *Girl Returning from the Market*, 1738. Oil on canvas, 46.7 × 37.5 cm (18⅜ × 14⅞ in.). National Gallery of Canada, Ottawa

32r *Girl Returning from the Market*, 1738. Oil on canvas, 46 × 37 cm (18⅛ × 14⅝ in.). Stiftung Preussische Schlösser und Gärten, Berlin-Brandenburg

33a *Girl Returning from the Market*, 1739. Oil on canvas, 47 × 38 cm (18½ × 15 in.). Louvre

33b Gabriel de Saint-Aubin. *Girl Returning from the Market*. Sketch after Chardin's painting in *Livret du Salon de 1769*. BN

34 Louis-Michel Van Loo. *Portrait of Diderot*, 1767. Oil on canvas, 81 × 65 cm (31⅞ × 25⅝ in.). Louvre

35 *Dead Hare with Gamebag and Powder Flask*, c. 1726–30. Oil on canvas, 98 × 76 cm (38⅝ × 29⅞ in.). Louvre

CHAPTER 2

36 *Self-portrait with Eye-shade*, 1775. Pastel, 46 × 38 cm (18⅛ × 15 in.). Louvre

37 *The Draughtsman* or *Young Student Drawing*, c. 1733–4. Oil on canvas, 31 × 17 cm (12¼ × 6¾ in.). Kimbell Art Museum, Fort Worth

38a Nicolas Loir. *Allegory of the Foundation of the Académie Royale de Peinture et de Sculpture* (detail). Oil on canvas. Musée National du Château, Versailles

38b Houasse (the Younger). *Life Drawing at the Académie*. Drawing. Louvre

39 Gabriel de Saint-Aubin. *Models at the Académie de Saint-Luc*, c. 1774. Drawing. Louvre

40 *The Skate*, c. 1725–6. Oil on canvas, 114 × 146 cm (44⅞ × 57½ in.). Louvre

41 Gaspard Duché de Vancy. *Picturesque View of the Exhibition of Paintings and Drawings in the Place Dauphine*, 1780. Drawing. Musée Carnavalet, Paris

42 *The Buffet*, 1728. Oil on canvas, 194 × 129 cm (76⅜ × 50¾ in.). Louvre

42–3 Extract from a document recording the names of painters received by the Académie Royale, 1728. BN

44a *The Attributes of Battle Music*, 1767. Oil on canvas, 112 × 145.5 cm (44⅛ × 57⅛ in.). Private collection

44–5 Gabriel de Saint-Aubin. *The Salon of 1767*. Watercolour. Private collection

45a *The Attributes of Civil Music*, 1767. Oil on canvas, 112 × 145.5 cm (44⅛ × 57⅛ in.). Private collection

46l *Lady Sealing a Letter* (detail), c. 1733. Oil on canvas, 146 × 147 cm (57½ × 57⅞ in.). Stiftung Preussische Schlösser und Gärten, Berlin-Brandenburg

46r (detail) and **47** Etienne Fessard. *Lady Sealing a Letter*, 1738. Engraving after Chardin. BN

46–7 Announcement of the sale of a print after Chardin. *Mercure de France*, June 1755. Bibliothèque Historique de la Ville de Paris, Paris

48–9 Philippe Meunier. *The Gateway of the Louvre*. Oil on canvas. Musée Carnavalet, Paris

48bl Pierre Louis de Surugue. *The Inclination of her Age*, 1743. Engraving after Chardin. BN

48bc C.-N. Cochin (the Elder). *Little Girl with Cherries*, 1738. Engraving after Chardin. BN

48br François Bernard Lépicié. *Girl with a Shuttlecock*, 1742. Engraving after Chardin. BN

49a Charles-Nicolas Cochin (the Elder). *The Little Soldier*, 1738. Engraving after Chardin. BN

49bl François Bernard Lépicié. *The Schoolmistress*, 1740. Engraving after Chardin. BN

49br Pierre Louis de Surugue. *Card Games*, 1744. Engraving after Chardin. BN

50 *The Diligent Mother*, Salon of 1740. Oil on

canvas, 49 × 39 cm (19¼ × 15⅜ in.). Louvre

50–1 'Royal warrant granting lodgings in the galleries of the Louvre to Le Sieur Chardin, 27 May 1757.' Archives Nationales, Paris

51 *The Attributes of the Arts*, 1765. Oil on canvas, 91 × 145 cm (35⅞ × 57⅛ in.). Louvre

52–3 *The Attributes of the Arts and Their Rewards*, 1766. Oil on canvas, 112 × 140.5 cm (44⅛ × 55⅜ in.). Hermitage, St Petersburg

54al Jean-Baptiste Marie Pierre. *Mercury in Love with Herse changes Aglauros to Stone…*, 1763. Oil on canvas, 325 × 329 cm (127⅞ × 129½ in.). Louvre

54ar Louis-Michel Van Loo. *The Painter Louis-Michel Van Loo and his Sister*, Salon of 1763. Oil on canvas, 245 × 162 cm (96½ × 63¾ in.). Musée National du Château, Versailles

54bl Jean-Baptiste Greuze. *The Paralytic*, Salon of 1763. Oil on canvas, 115.5 × 146 cm (45¼ × 57½ in.). Hermitage, St Petersburg

54bc Joseph Vernet. *Evening* or *Sunset*, Salon of 1763. Oil on canvas, 85 × 135 cm (33½ × 53⅛ in.). Musée National du Château, Versailles

54br *Grapes and Pomegranates*, Salon of 1763. Oil on canvas, 47 × 57 cm (18½ × 22½ in.). Louvre

55 Jean-Baptiste Greuze. *Septimius Severus Reproving Caracalla*, Salon of 1769. Oil on canvas, 124 × 160 cm (48⅞ × 63 in.). Louvre

56a *The Monkey as Painter*, c. 1738–40. Oil on canvas, 73 × 59.5 cm (28¾ × 23½ in.). Louvre

56b *Tinplated Copper Cauldron, Pepper Mill, Leek, Three Eggs and a Casserole*, c. 1733. Oil on wood, 17 × 21 cm (6¾ × 8¼ in.). Louvre

57 *Pestle and Mortar, Bowl, Two Onions, Copper Cauldron and a Knife*, c. 1734–5. Oil on wood, 17 × 23 cm (6¾ × 9 in.). Musée Cognacq-Jay, Paris

58 Bill relating to the payment for *The Bird Organ*, 1751. Archives Nationales, Paris

59 *The Bird Organ*, Salon of 1751. Oil on canvas, 50 × 43 cm (19⅝ × 16⅞ in.). Louvre

CHAPTER 3

60 *Self-portrait* or *Chardin at the Easel*, c. 1779. Pastel, 40.5 × 32.5 cm (16 × 12⅞ in.). Louvre

61 Philippe Rousseau. *Chardin and his Models*, 1867. Oil on canvas, 177.5 × 226 cm (70 × 89 in.). Musée d'Orsay, Paris

62 *Lady Sealing a Letter*, 1733. Oil on canvas, 146 × 147 cm (57½ × 57⅛ in.). Stiftung Preussischer Kulturbesitz, Berlin

63a Jean-Baptiste Greuze. *The Village Bride*, Salon of 1761. Oil on canvas, 92 × 117 cm

(36¼ × 46⅛ in.). Louvre

63b François Boucher. *La Belle Cuisinière*. Oil on canvas. Musée Cognacq-Jay, Paris

64a *The Good Education* (detail), 1749. Oil on canvas, 41 × 47 cm (16⅛ × 18½ in.). Museum of Fine Arts, Houston

64b *The Scullery Maid*, 1738. Oil on canvas, 45.4 × 37 cm (18 × 14⅝ in.). Hunterian Art Gallery, University of Glasgow

65 *The Young Draughtsman*, 1737. Oil on canvas, 80 × 65 cm (31½ × 25⅝ in.). Louvre

66 *Portrait of the Painter Joseph Aved*, also known as *Le Souffleur*, *The Chemist* and *The Philosopher*, 1734. Oil on canvas, 138 × 105 cm (54⅜ × 41⅜ in.). Louvre

67a and **67b** (detail) *Young Man with a Violin*, c. 1734–5. Oil on canvas, 67.5 × 74.5 (26⅝ × 29⅜ in.). Louvre

68 *The Governess* (detail), 1738. Oil on canvas, 46.7 × 37.5 cm (18⅜ × 14⅞ in.). National Gallery of Canada, Ottawa

69l *The Good Education*, 1749. Oil on canvas, 41 × 47 cm (16⅛ × 18½ in.). Museum of Fine Arts, Houston

69r *Girl Returning from the Market* (detail), 1739. Oil on canvas, 47 × 38 cm (18½ × 15 in.). Louvre

70 *Saying Grace*, c. 1740. Oil on canvas, 49.5 × 39.5 cm (19½ × 15⅝ in.). Louvre

71 *The Governess*, 1738. Oil on canvas, 46.7 × 37.5 cm (18⅜ × 14⅞ in.). National Gallery of Canada, Ottawa

72 *Girl with a Shuttlecock*, Salon of 1737. Oil on canvas, 81 × 65 cm (31⅞ × 25⅝ in.). Private collection, Paris

73 *The House of Cards*, Salon of 1737. Oil on canvas, 82 × 66 cm (32¼ × 26 in.). Andrew W. Mellon Collection, © 1999 Board of Trustees, National Gallery of Art, Washington, D. C.

74a *Soap Bubbles* or *Bottles of Soap*, c. 1734. Oil on canvas, 60 × 73 cm (23⅝ × 28¾ in.). Los Angeles County Museum of Art

74b *Saying Grace* (detail), c. 1740. Oil on canvas, 49.5 × 39.5 (19½ × 15⅝ in.). Louvre

75 *Child with a Spinning Top* (detail), c. 1737. Oil on canvas, 67 × 76 cm (26⅜ × 29⅞ in.). Louvre

76 *The Drawing Lesson*, also known as *The Diligent Student*, 1748. Oil on canvas, 41 × 47 cm (16⅛ × 18½ in.). Fuji Art Museum, Tokyo

76–7 *Still Life with Carafe, Silver Tumbler, Peeled Lemon, Apples and Pears*, c. 1728. Oil on canvas, 55 × 46 cm (21⅝ × 18⅛ in.). Staatliche Kunsthalle, Karlsruhe

77a *Dead Partridge, Pear and Noose on a Stone Table*, 1748. Oil on canvas, 39 × 45.5 cm (15⅜

× 18 in.). Städelsches Kunstinstitut, Frankfurt
77b *Seville Orange, Silver Tumbler, Apples, Pear and Two Bottles*, c. 1750. Oil on canvas, 38 × 46 cm (15 × 18⅛ in.). Private collection, Paris
78a *Bacchante Milking a Goat Held by a Child*, Salon of 1769. Oil on canvas, 53 × 91 cm (20⅞ × 35⅞ in.). Private collection
78b Roland Delaporte. *Preparations for a Country Lunch*, Salon of 1763. Oil on canvas, 92 × 73 cm (36¼ × 28¾ in.). Louvre
79 *The Kitchen Table*, c. 1756. Oil on canvas, 31.5 × 40.5 cm (12½ × 16 in.). Musée Thomas Henry, Cherbourg
80a Jean-Baptiste Oudry. *Hare and Leg of Lamb*, 1742. Oil on canvas, 98.2 × 73.5 cm (38⅞ × 28⅞ in.). The Cleveland Museum of Art, Cleveland
80b (detail) and **80–1** *Dead Rabbit with Copper Cauldron, Quince and Two Chestnuts*, c. 1738. Oil on canvas, 69 × 56 cm (27⅛ × 22 in.). Nationalmuseum, Stockholm
82 (detail), **82–3** and **83** (detail) *Jar of Olives*, 1760. Oil on canvas, 71 × 98 cm (28 × 38⅝ in.). Louvre
84 *The Copper Cistern*, c. 1734. Oil on wood, 28.5 × 23 cm (11¼ × 9 in.). Louvre
85a *Basket of Peaches, Black and White Grapes, with Cooler and Stemmed Glass*, c. 1759. Oil on canvas, 38.5 × 47 cm (15⅛ × 18½ in.). Musée des Beaux-Arts, Rennes
85b *The Brioche*, 1763. Oil on canvas, 47 × 56 cm (18½ × 22 in.). Louvre
86–7 *The Smoker's Box* or *Pipes and Tumbler*, c. 1737. Oil on canvas, 32.5 × 42 cm (12⅞ × 16½ in.). Louvre
88–9 *The White Tablecloth* or *The Saveloy*, c. 1732. Oil on canvas, 96 × 124 cm (37¾ × 48⅞ in.). The Art Institute of Chicago
90a *Jar of Apricots*, 1758. Oil on oval canvas, 57 × 51 cm (22½ × 20⅛ in.). Art Gallery of Ontario, Toronto
90b (detail) and **91** *Basket of Wild Strawberries*, Salon of 1761. Oil on canvas, 38 × 46 cm (15 × 18⅛ in.). Private collection, Paris
92l *Portrait of a Young Girl*, 1776. Pastel, 45 × 37.5 cm (17¾ × 14⅞ in.). Private collection, New York
92r *Portrait of a Young Boy*, 1776. Pastel, 45 × 37.5 cm (17¾ × 14⅞ in.). Private collection, New York
93 *Portrait of Madame Chardin*, 1775. Pastel, 46 × 38.5 cm (18⅛ × 15¼ in.). Louvre
94a *Self-portrait*, also known as *Portrait of Chardin with Spectacles* (detail), 1771. Pastel, 46 × 37.5 cm (18⅛ × 14⅞ in.). Louvre

94b *Dead Rabbit with Gamebag and Powder Flask*, c. 1727–8. Oil on canvas, 81 × 65 cm (31⅞ × 25⅝ in.). Louvre
94–5 *Self-portrait with Eye-Shade* (detail), 1775. Pastel, 46 × 38 cm (18⅛ × 15 in.). Louvre
95a *Self-portrait* or *Chardin at the Easel*, c. 1779. Pastel, 40.5 × 32.5 cm (16 × 12⅞ in.). Louvre
95b Edouard Manet. *The Rabbit*, 1866. Oil on canvas, 62 × 48 cm (24⅜ × 18⅞ in.). Angladon-Dubrujeaud Foundation, Avignon
96 *Vase of Flowers* (detail), c. 1755–60? Oil on canvas, 44 × 36 cm (17⅜ × 14⅛ in.). National Gallery of Scotland, Edinburgh

DOCUMENTS

97 *Vase of Flowers*, c. 1755–60? Oil on canvas, 44 × 36 cm (17⅜ × 14⅛ in.). National Gallery of Scotland, Edinburgh
100a Jean-Baptiste Marie Pierre. *Mercury in Love changes Aglauros to Stone…* (detail), 1763. Oil on canvas, 325 × 329 cm (127⅞ × 129½ in.). Louvre
100b Page from the Salon catalogue. BN
101 *Grapes and Pomegranates* (detail), Salon of 1763. Oil on canvas, 47 × 57 cm (18½ × 22½ in.). Louvre
102 *Visitors at the Salon*, 18th century. Engraving. BN
103 *Perspective View of the Salon of the Académie Royale de Peinture et de Sculpture*, 18th century. Engraving. Musée Carnavalet, Paris
105 Jean-Honoré Fragonard. *Portrait of Diderot*. Oil on canvas, 81.5 × 65 cm (31⅞ × 25⅝ in.). Louvre
106 *The Kitchen Table* (detail), c. 1756. Oil on canvas, 31.5 × 40.5 cm (12½ × 16 in.). Musée Thomas Henry, Cherbourg.
107a and **107b** (detail) Louis Le Nain. *The Happy Family* or *After the Baptism*, 1642. Oil on canvas, 61 × 78 cm (24 × 30¾ in.). Louvre
108l Willem van Mieris. *Soap Bubbles*. Oil on canvas, 32 × 26.5 cm (12⅝ × 10½ in.). Louvre
108r *Soap Bubbles* (detail), c. 1734. Oil on canvas, 60 × 73 cm (23⅝ × 28¾ in.). Los Angeles County Museum of Art
109l Gabriel Metsu. *Woman Peeling Apples*, 17th century. Oil on wood, 28 × 26 cm (11 × 10¼ in.). Louvre
109r *Woman Peeling Vegetables*, 1738. Oil on canvas, 46.2 × 37.5 cm (18⅛ × 14⅞ in.). National Gallery of Art, Samuel H. Kress Collection, Washington, D. C.
119 *Self-portrait with Eye-shade* (detail), 1775. Pastel, 46 × 38 cm (18⅛ × 15 in.). Louvre

INDEX OF CHARDIN'S WORKS

Page numbers in *italics* relate to illustrations or references in captions.

A

Amusements of Private Life, The 31, 51

Attributes of Battle Music, The 45

Attributes of Civil Music, The 45

Attributes of Music, The (Salon of 1765) 29, *51*

Attributes of the Arts, The (Salon of 1765) 29, 51

Attributes of the Arts and Their Rewards, 51, *52*, 76

Attributes of the Sciences, The (lost) 29, *51*

B

Bacchante Milking a Goat Held by a Child 78

Basket of Grapes (Salon of 1765) 29

Basket of Peaches, Black and White Grapes, with Cooler and Stemmed Glass, 83, 85

Basket of Plums with Nuts, Currants and Cherries (Salon of 1765) 29

Basket of Wild Strawberries 91, 91

Bird Organ, The 51, 58, 59, 67

Brioche, The 85, 85, 112

Buffet, The 42, 43, *43*, 95, 113

C–D

Child with a Spinning Top 27, 28, 66, *66*

Cistern, The, see *Woman Drawing Water from a Copper Cistern 43*

Copper Cistern, The 84, *84*, 95

Dead Hare with Gamebag and Powder Flask 34

Dead Partridge, Pear and Noose on a Stone Table 76, *76*

Dead Rabbit with Copper Cauldron, Quince and Two Chestnuts 81

Dead Rabbit with Gamebag and Powder Flask 95

Diligent Mother, The 50, 51, 59, 68

Diligent Student, The (see *The Drawing Lesson) 76*

Draughtsman, The, also known as *Young Student Drawing 37*, 66

Drawing Lesson, The 76, 76

Duck with Seville Orange 11

G–H

Game of Billiards 16, *17*

Girl Returning from the Market 33 (Ottawa, Berlin, Louvre), 68

Girl with a Shuttlecock 75

Good Education, The 65, 67, 68, 76

Governess, The 68, *68*

Grapes and Pomegranates 54, 85, *100*, 101

Hound, The 67

Household Accounts, The 111

House of Cards, The (Washington, D.C.) 73, *75*

House of Cards, also known as *The Son of M. Le Noir Building a House of Cards* (London) 26, 28

House of Cards, The (Louvre) 43

J–M

Jar of Apricots 90

Jar of Olives 82, *82*, 85, 101, 113

Kitchen Table, The 79, 106

Lady Sealing a Letter 20, 46, *46*, 47, 62, 63

Lady Taking Tea 20, 66

Male Nude 19, 19

Monkey as Painter 56

Morning Toilet, The 30, 31

P

Pantry Table, The 84

Pestle and Mortar, Bowl, Two Onions, Copper Cauldron and a Knife 57

Philosopher, The, see *Portrait of the Painter Joseph Aved 67*

Pipes and Tumbler see *The Smoker's Box 87*

Portrait of Madame Chardin 92

Portrait of the Painter Joseph Aved 67, *69*

Portrait of a Young Boy 93

Portrait of a Young Girl 93

S

Saying Grace 51, 59, 68, 75, 95

Scullery Maid, The 64, 64

Self-portrait, also known as *Chardin at the Easel 61*, 94, *94*

Self-portrait, also known as *Portrait of Chardin with Spectacles 13*, 94

Self-portrait with Eye-shade 37, 94

Servant Filling a Player's Glass 16

Seville Orange, Silver Tumbler, Apples, Pear and Two Bottles 77

Skate, The 40, 42, 43, *43*, 78, 83, *89*, 95, 102, 113

Smoker's Box, The 87

Soap Bubbles, also known as *Bottles of Soap 74*, 75, *108*

Souffleur, Le, see *Portrait of the Painter Joseph Aved 65*, 67

Still Life with Carafe, Silver Tumbler, Peeled Lemon, Apples and Pears 77

T–Y

Tinplated Copper Cauldron, Pepper Mill, Leek, Three Eggs and a Casserole 57

Vase of Flowers 95, 96, *97*, 105

Vinaigrette, The 19

Washerwoman, The 43

White Tablecloth, The 89

Woman Drawing Water from a Copper Cistern, also known as *The Cistern 43*

Woman Peeling Vegetables 109

Young Draughtsman, The 64, 64

Young Man with a Violin 66, *66*, 74

GENERAL INDEX

A–C

Abecedario (Mariette)
 14, 106
Académie de Saint-Luc,
 Paris, 19, *28*, 39, *39*
Académie of Rouen 15,
 16
Académie Royale de
 Peinture et de
 Sculpture, Paris, 14,
 15, *15*, 16, *18*, 19, 24,
 25, *25*, 28, *28*, 29, 37,
 38, *38*, 39, *39*, 40, 43,
 43, 46, *50*, 51, *52*, 55,
 55, 57, 58, *64*, 93
Academy of Arts, St
 Petersburg 51, *52*
*Allegory of the
 Foundation of the
 Académie Royale de
 Peinture et de Sculpture*
 (Loir) *38*
Angiviller, Comte d'
 92
Année littéraire, L' 85,
 92
Aved, Joseph *18*, 28, 47,
 65, *67*, *89*
Belle Cuisinière, La
 (Boucher) *63*
Blanc, Charles 109
Boscry, Pierre (architect)
 50
Bouchardon Edmé
 (sculptor) 47, *51*
Boucher, François 32,
 41, 63, *63*
British Magazine 26
Caroline Louise
 (Margravine of Baden)
 51
Catherine the Great of
 Russia 51, *52*, 75
Cazes, Pierre-Jacques
 18, *18*, 19
Cézanne, Paul *56*, 95,
 95
Challe, Michel Ange
 101

Champfleury, Jules
 Husson 108
Chardin, Jean (father)
 17, 18
Chardin Jean-Pierre
 (son) 20, 21, 22, *22*,
 23, *23*
Chardin, Marguerite
 Agnès (daughter) 20
Château de Bellevue
 45, 51, 78
Château de Choisy *29*,
 51, *51*, *52*, 78
Château de
 Fontainebleau 19
City of Paris, The
 (Bouchardon) *51*
Cochin, Charles-
 Nicolas (junior) 15,
 15, 16, *16*, 17, 20, 21,
 22, 25, *25*, 26, 27, 28,
 42, *50*, 98–9
Cochin, Charles-
 Nicolas (senior) 16,
 46
Colbert, Jean-Baptiste
 38
Coypel, Charles-
 Antoine 58
Coypel, Noël-Nicolas
 19, 31, 41, 47, 56
Crozat, Baron de Thiers
 (collector) 16

D–H

Daumier, Honoré *16*
Dead Bird, The (Greuze)
 63
Delaporte, Roland 79,
 79
Desfriches, Aignan
 Thomas 50
Desportes, Alexandre-
 François *43*, 102
Diderot, Denis 13, 14,
 15, 23, *23*, 27, 29, *29*,
 30, 33, *34*, *51*, *52*, 58,
 67, 76, 82, *82*, *83*, 85,
 90, 92, 99, 100–3,
 104–5, *105*

Duquesnoy, François 47
Dusaulchoy 99
Eloge (Haillet de
 Couronne) 15, 16
'Essai sur la vie de M.
 Chardin' (Cochin) 15
Estève, Pierre (critic) *67*
Falconnet, Etienne
 (sculptor) *23*
Félibien, André 55
Fessard, Etienne 46, *46*,
 47
Fragonard, Jean Honoré
 63, *104*
Fréron, Elie 85
Freud, Lucian 114, 115
Geminiani, Francesco
 (musician) 50
Giacometti, Alberto
 115
Gide, André 84
Godefroy, Charles
 (jeweller) 28, 66
Godefroy, Charles
 Théodose 66
Goncourt, Jules and
 Edmond de 15, *33*,
 92, 97, 109, 110
Greuze, Jean-Baptiste
 34, *54*, 55, 63, *63*, *82*,
 102
Grimm, Baron
 Melchior von *67*
Haillet de Couronne
 15, 16, 17

L–O

Lady Sealing a Letter
 (Fessard) 46
La Font de Saint-Yenne
 (critic) 31
Lafosse, Charles de *18*
Lancret, Nicolas 41, 47,
 106
Laperlier, Laurent
 (collector) 89
Largillierre, Nicolas de
 42, 108
La Tour, Georges de 59
La Tour, Maurice

Quentin de *25*, 27
Le Bas, Jacques-Philippe
 (engraver) 47
Le Blanc, Jean Bernard
 106–7
Le Brun, Charles *18*, 47
Leclerc, Sébastien 58
Le Lorrain Louis-Joseph
 47
Le Lorrain, Robert
 (sculptor) 47
Lemoyne, François
 (sculptor) 41, 47–50
Le Noir (dealer) 28, 66
Lépicié, François
 Bernard *26*, 27
Le Sueur, Eustache 47
Little Girl with Cherries
 (Cochin senior) 46,
 48
Little Soldier, The
 (Cochin senior) 46,
 49
Loir, Nicolas 38
Louis XIV *38*
Louis XV 21, *25*, 29,
 45, 51, 59
Louis XVI 55
Louisa Ulrica, Queen
 of Sweden 31, *31*,
 51
Louvre 16, *21*
Louvre (galleries) *50*
Louvre (gateway) *49*
Manet, Edouard 95, *95*
Mariette, Pierre-Jean
 14, 15, *32*, 46, *49*, *89*,
 106
Marigny (Marquis de)
 15, *50*, 92
Matisse, Henri *43*, 95
Mehemet Effendi
 (known as Said Pacha)
 30–1
Mercure de France 27,
 68, 107, 112
Mercury (Pigalle) 50,
 52, *76*
Meunier, Philippe *49*
Morandi, Giorgio 114,
 115

Nattier, Jean-Marc 58
Oudry, Jacques-Charles 28
Oudry, Jean-Baptiste 41, 58, 79, *81*, 82

P–R

Paralytic, The (Greuze) 63
Paris, 17, *18*, *21*, 23, 28, 39, 41, 50, 51
Paulmy, Marquis de 23
Pierre, Jean-Baptiste Marie *54*, 57, 93, 98, 100, 102
Pigalle, Jean-Baptiste (sculptor) 50, *52*, 76
Place Dauphine *40*, 41, *41*, 42
Ponge, Francis 114, 115
Portrait of Mademoiselle Mahon (engraving) *66*
Potsdam *47*
Pouget, Françoise Marguerite (Chardin's second wife) 20, *21*
Poussin, Nicolas, 47, 55
Preparations for a Country Lunch (Delaporte) *79*
Primaticcio, Francesco 19
Proust, Marcel 75,

94, 114
Reff, Theodore 116–7
Rembrandt van Rijn *67*, *89*, 92
Restout, Jean Bernard 58
Rosso, Fiorentino 19
Rothenbourg, Conrad Alexandre de (Comte) 46, 51, 78
Rousseau, Philippe *43*, *61*
Rubens, Pierre Paul *23*, 24

S–T

Saintard, Marguerite (Chardin's first wife) 20, *20*
Saint-Aubin, Gabriel de *28*, *39*, *45*, *91*
Saint Barthélémy (procession) *41*
Saint-Germain-des-Près *21*
Salon *28*, 41, 42, *43*, *45*, 47, *55*, 76, *76*, 90, *102*, *103*
Salon de la Jeunesse 41, 43; (1732) 43, 47; (1734) 43, 47
Salon of 1737 46, *67*
Salon of 1739 *68*

Salon of 1740 *68*
Salon of 1741 *26*
Salon of 1748 76, *76*
Salon of 1751 31, *58*
Salon of 1753 *67*, *68*
Salon of 1757 76
Salon of 1759 104
Salon of 1761 *91*, 104
Salon of 1763 82, *82*, 85, *100*, 105
Salon of 1765 *29*, *51*, 99, 105
Salon of 1767 *45*, *55*
Salon of 1771 *92*, 105
Salon of 1773 76
Salon of 1775 105
Salon of 1777 *93*
Salon of 1779 92
Salon of 1763 (Diderot) *83*, 105
Salon of 1765 (Diderot) 23, 76, 105
Salon of 1765 (Saint-Aubin) *28*
Sterling, Charles *87*, *95*
Surgeon's Signboard, The (Jules de Goncourt) *19*
Sweden 31, 51
Sylvestre, Jacques-Augustin 47, 58
Teniers, David, the Younger 47, *56*, 106
Tessin, Carl Gustaf

(Count) 31, *31*, 32, 33, 51
Thoré (W. Bürger) *43*, 108
Titus-Carmel, Gérard 114, 115
Trouard, Louis-François (architect) 50

V–W

Van Gogh, Vincent 95
Van Loo, Carle 19, 58
Van Loo, Jean-Baptiste 19, 47
Van Loo, Louis-Michel *34*, *54*
Van Opstal, Gérard *78*
Venice 23
Vermeer Jan *43*
Vernet, Joseph 29, *54*, 90
Versailles *18*, 51
Vien, Joseph Marie (painter) 27, 98, 101
Village Bride, The (Greuze) 63, *63*
Vouet, Simon 39
Watteau, Antoine *56*
Wenzel of Liechtenstein, Prince Joseph 51
Wouwerman, Philips 47, 106

PHOTO CREDITS

Pierre Rosenberg
is director of the Louvre and has been a member of
the Académie Française since 1995.
A specialist in 17th- and 18th-century French and
Italian painting and drawing, he has organized
numerous exhibitions, notably on Watteau (1984–5);
Subleyras (1987); Fragonard (1987–8); La Hyre
(1988); Poussin (1994); and La Tour (1997–8).
In collaboration with Louis-Antoine Prat, he
has produced *catalogues raisonnés* of the drawings
of Poussin (1994), Watteau (1996), David,
Fragonard and Ingres. The leading French specialist on
Chardin, he was the chief administrator for both the
Chardin retrospective of 1979 and the major
exhibition held at the Grand Palais, Paris, in 1999.

Hélène Prigent
works for the Réunion des Musées Nationaux, Paris,
and was in charge of public relations for the 'Chardin'
exhibition held at the Grand Palais, Paris, in 1999. She
is the author of a CD-Rom *Chardin, La Bénédicité*
(1999), and is currently preparing a work on
Chardin and Diderot.

Translated from the French by Jane Brenton

First published in the United Kingdom in 2000 by
Thames & Hudson Ltd, 181A High Holborn,
London WC1V 7QX

English translation © 2000 Thames & Hudson Ltd,
London

© 1999 Gallimard/RMN

British Library Cataloguing-in-Publication Data

A catalogue record for this book is available
from the British Library

ISBN 0–500–30098–4

Printed and bound in Italy
by Editoriale Lloyd, Trieste